Library of Congress Cataloging-in-Publication Data

Freund, James C., 1934-
 Slices of the Big Apple : a photographic tour of the streets of New York / James Freund.
 p. cm.
 ISBN 0-8232-2397-3 (pb)
 1. Street photography – New York (State) – New York. 2. New York (N.Y.) – Pictorial works.
 3. Manhattan (New York, N.Y.) – Pictorial works. 4. Freund, James C., 1934- I. Title.

TR659.8.F74 2004
779'.4747'1092 – dc22

 2004054292

Design by Bert Waggott

Printed in the United States of America

10 9 8 7 6 5 4 3 2 1
First Edition

Title Page:
The montage on the title page is a detail from the poster used for the
author's exhibition of New York photographs at the National Arts Club
in June 2003 (see page 133).

Contents Facing Page:
This is a black & white wintertime view of Central Park's Bethesda Terrace.

Front Endpaper:
This panoramic northeast view of Manhattan was taken from the top
of the Empire State Building.

Rear Endpaper:
This panoramic southeast view of Manhattan was taken from the top
of the Empire State Building.

Slices of the Big Apple

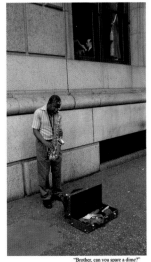

"Brother, can you spare a dime?"

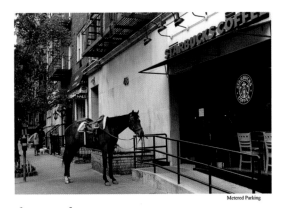

Metered Parking

*A Photographic Tour
of the
Streets of New York*

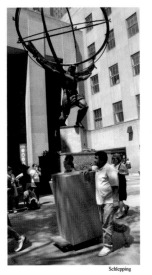

Schlepping

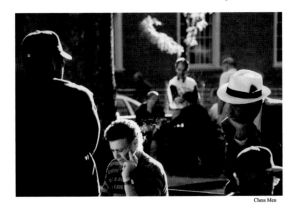

Chess Men

James Freund

FORDHAM UNIVERSITY PRESS · NEW YORK · 2004

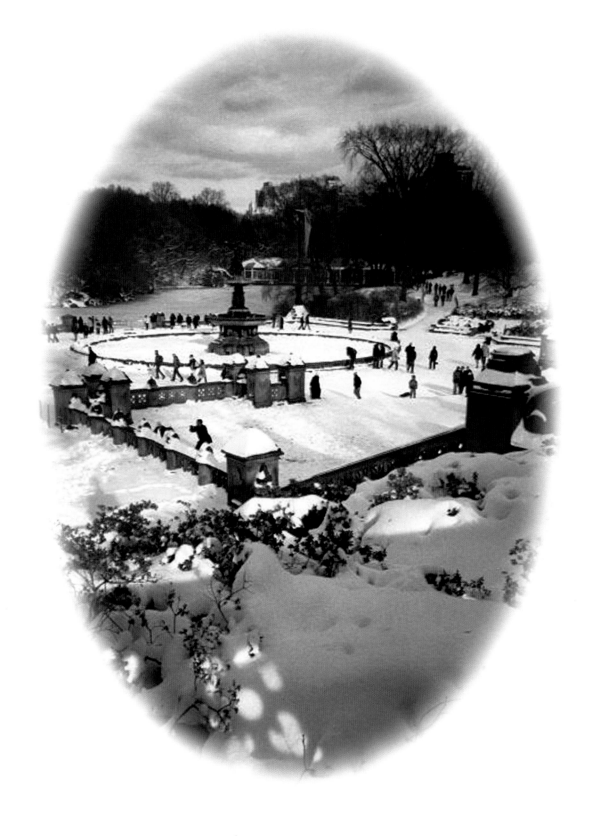

Contents

1 Introduction *1*

2 Juxtapositions *13*

3 Sights of the City *21*

4 The Inhabitants *63*

5 Telling Tales *89*

6 Tips on Photographing the Big Apple *103*

On a Personal Note *129*

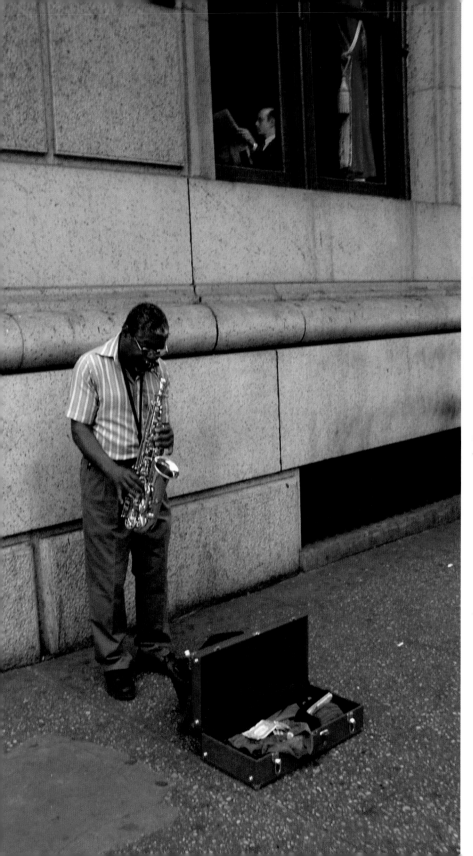

"Brother, can you spare a dime?"

This was the signature photo in the exhibit that led to this book (see "On a Personal Note"), and it remains my individual favorite. There's something so deliciously ironic about the juxtaposition between the street musician working the pavement for quarters from passersby, while the banker (or whoever) sits framed in the window of his elegant private club reading the Financial Times – each oblivious of the other. I just stumbled upon the scene one day a few years ago, and I've been on the lookout ever since for something to match it.

1 / Introduction

For a photographer, there's no city quite like New York.

There are more beautiful cities – Paris and Sydney, to name but two. Others, like Rome, are more monumental or more suffused in history – London springs to mind. New York doesn't win any prizes for quaintness, for cleanliness, for an abundance of quiet places, or for the quality of its air.

But – at least for a native New Yorker like myself – no place else can match the broad array of photographic opportunities presented by the streets of New York. East side, west side, all around the town. . . .

It's not just the streets, however – nor the buildings, nor the parks. The prime photographic ingredient in New York is the people. The term "melting pot" may have become a cliché, but the diversity, the expressiveness, the magnetism provided by the inhabitants of this city – as well as its visitors – are truly something to witness.

And that's what I've tried to capture in *Slices of the Big Apple*. As the sub-title indicates, this is a photographic tour of the streets of New York, but with an emphasis on its people.

I should note at the outset that although New York City is comprised of five boroughs, all the pictures in this book relate to Manhattan. There's a lot to photograph in the other boroughs, I'm sure, but I've saved that for future projects.

Although most of the photos in the book were taken in color, I have a healthy respect for black & white. And in New York, certain subject matter lends itself especially well to that medium – as you'll see in these pages.

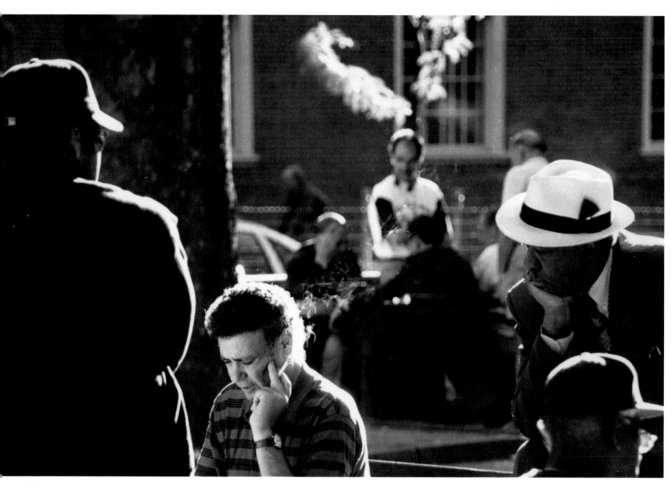

Chess Men

This is my favorite black & white photograph in the book – it wouldn't have the same impact in color. Notice how the intensity of the expressions on the faces of the chess players and kibitzers is heightened by the effect of the late afternoon light striking their heads and hats, as well as the puffs of smoke. When I took this Washington Park picture about ten years ago, I included the chessboard in the foreground; but because some out-of-focus fence posts got in the way, I cropped the lower part of the image. Nowadays, in the digital age – discussed in Chapter 6 – it would have been simple enough to keep the chessboard in the picture while eliminating the fence posts. In retrospect, though, I prefer the composition this way, since it heightens the priority status of the men's faces.

Schlepping

This is a case of a little patience – a quality I don't always possess – paying off. My plan was to include in the frame something that would furnish a striking contrast to the Fifth Avenue statue of Atlas carrying the world on his shoulders. So I waited at the edge of the sidewalk for about a half hour, not even sure of what I was seeking – perhaps a father shouldering his child. . . . But no one of interest passed by. An added problem was the large number of pedestrians in the vicinity – even if something noteworthy were to happen, I was concerned that the image would likely be blocked by other strollers. And then, in one magical moment, the pedestrians thinned out and this gentleman happened by, propelling his heavy load on a wheeled cart – ah, progress! – and I had my shot.

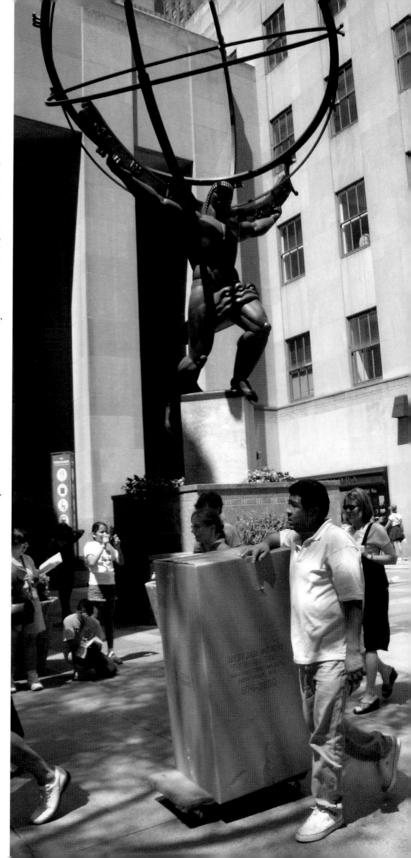

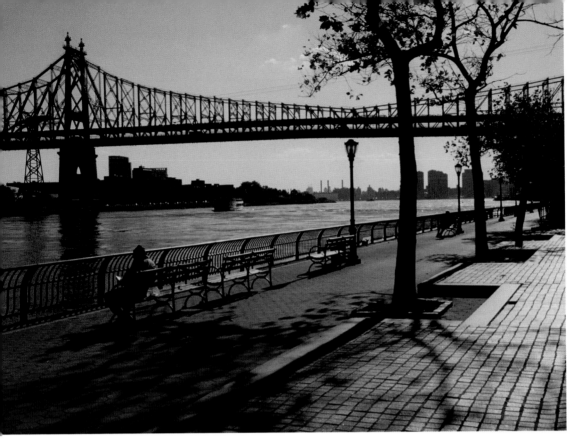

East Side Reading Room

(Captions on facing page)

Avenue Park

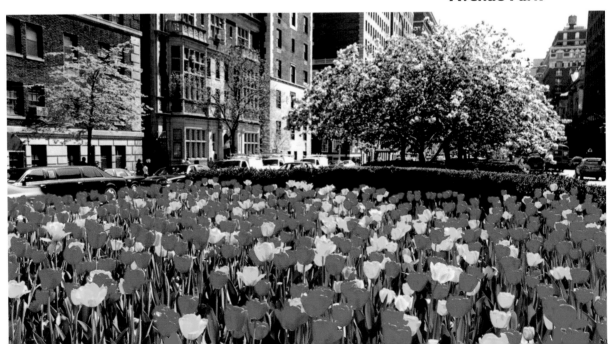

You'll be seeing some familiar sights here, to be sure, but in a somewhat different light than you've previously experienced. You may also come across some not-so-familiar scenes that you've failed to notice. I think you'll be more aware of some of the ironies our town offers – as well as some of the humor, the pathos, and the human interest. My hope is that this book tempts you into unsheathing your own camera and taking it along as you walk the streets of this great city – you never know when you'll see something memorable and want to record it.

On this last point, I feel strongly that photography shouldn't be something mysterious or aloof or reserved for professionals. In fact, it's the most accessible of the arts, open to everyone. And yet what I find is that, other than snapping obligatory family shots and occasional travel highlights, relatively few people take advantage of what's so available right in their backyard. As a result, many of my captions contain explanatory material, and I've included an entire chapter (No. 6) of tips on how to go about photographing the city, which I think you'll find helpful.

FACING PAGE

In this mainly vertical city, it's not always easy to find an open-air wide-angle street-level vista. But the promenade alongside the East River (top) is a welcome exception, especially when the day is sparkling and there's a convenient bridge furnishing a background silhouette. The solitary reader on the bench serves to humanize the scene as well as provide an apt title for the picture.

Once a year, every spring, this is the way Park Avenue looks (bottom). But to get the full effect of the spectacle, you have to crouch down low and let the colorful tulips fill the bottom half of the frame. By the way, although the top photo would have worked almost equally well in black & white (remember those striking scenes from Woody Allen's Manhattan*), the bottom photo, for obvious reasons, wouldn't translate.*

Manhattan from Staten

Here's a telescopic view of the southern tip of Manhattan island (and oh, yes, a colorful vessel to boot), taken from a perch near the Verrazano Bridge on Staten Island.

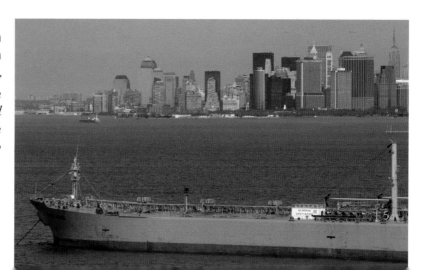

In the photographic iconography of New York, there's no venue quite like Times Square. In addition to all the usual reasons – familiar attractions, bizarre residents, plentiful juxtapositions – it's the one area where you and your camera don't stand out, since so many tourists are snapping away. So, if you feel any embarrassment about photographing people on the street, this is as good a place as any to get your feet wet.

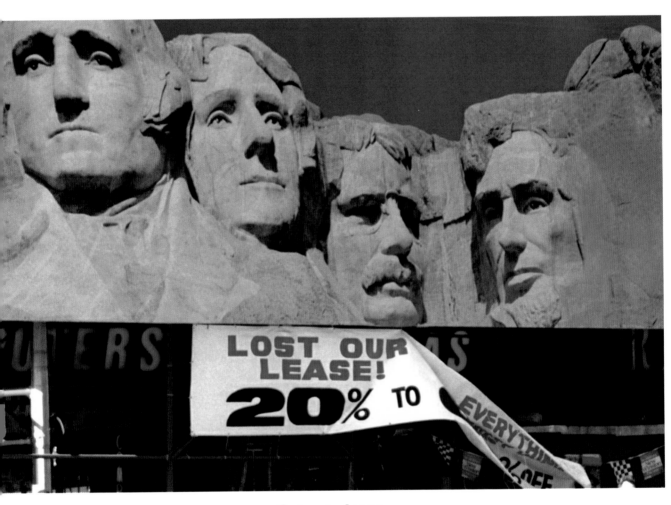

Cut-rate Icons

This Times Square scene caught my eye one day – the billboard replica of Mt. Rushmore, with the drooping "Lost Our Lease" banner just below. Taken together, the scene made me reflect that in today's distinctly non-heroic world, just about everything is going for 20% off.

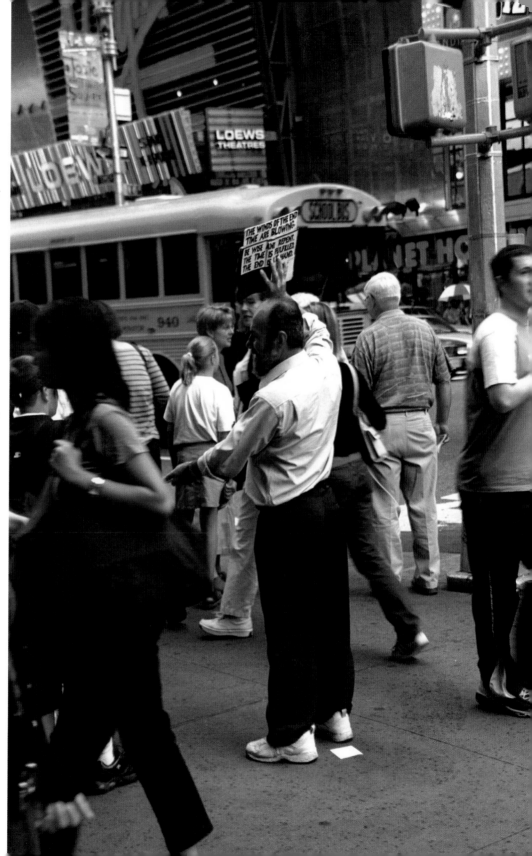

Curbside Cassandra

Two aspects of this photograph appeal to me. First, the incongruity of this man choosing the bustling, pagan center of Times Square to proclaim the end of the world in such earnest fashion. Second – and what really makes the picture work – the studied indifference of New Yorkers to his startling pronouncement. Just look at everyone doing his or her own thing, totally ignoring the prophet (with one exception – the man whose face is directly below the placard and whose footwear matches that of the oracle). Even the school bus adds to the energetic anarchy of the scene.

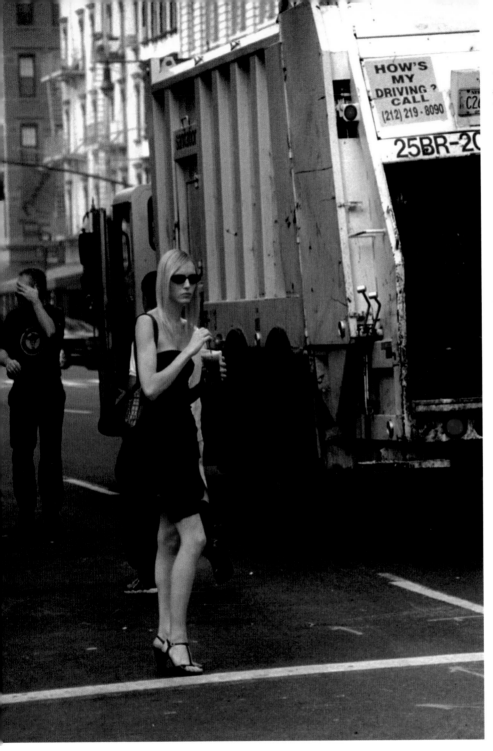

Here's another of my personal favorites. The scene takes place near where I live on the Upper West Side. I hadn't set out to photograph that day, but was carrying a camera just in case something caught my eye. Naturally, my gaze was drawn to the slim attractive woman in the middle of the intersection, but I doubt I would have photographed her if it weren't for what I then saw looming in the background – the hulking, not-so-attractive garbage truck. I didn't hesitate – you only get a few seconds to grab a shot like this. By the way, I like to speculate on the garbage man's hand-to-his-face gesture: did he spot me and try to avoid being photographed, or was he just blinded by the beautiful sight before him, or was it something else entirely? That's one of the joys of photographing on New York's streets – the speculation you can indulge in later on.

Beauty and the Beast

Eleanor
in Ermine

*When the white
stuff falls in New
York City, you
have to move
quickly to get some
good photos before
the resolute snow
removal efforts
and warming
temperatures turn
what's left on the
streets to slush
and eradicate the
picturesque white
crowns adorning
trees, statuary and
other fixed objects.
Here, at the 72nd
Street entrance to
Riverside Park,
Eleanor Roosevelt
is deep in thought
and outlined
in snowflakes —
forming
a notable
contrast to her
contemplative
summertime
counterpart on the
facing page.*

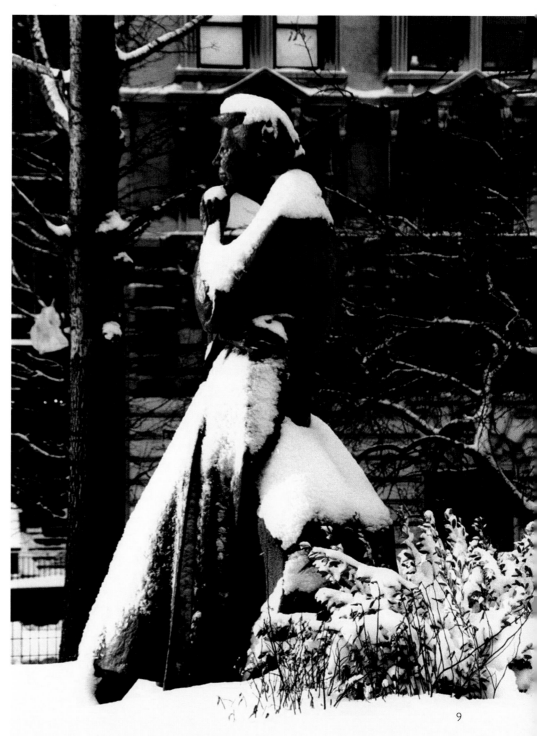

9

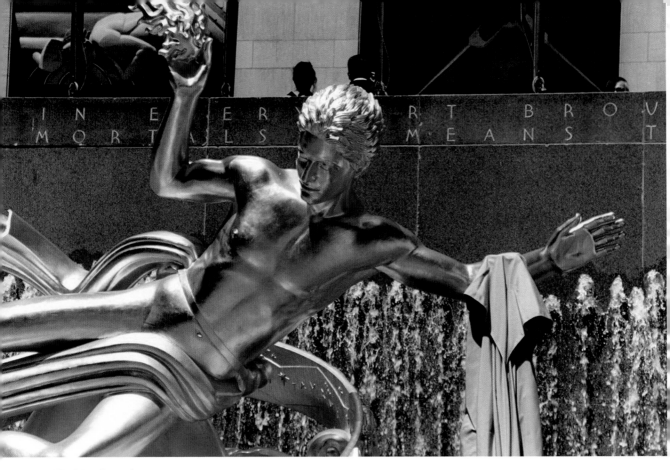

Table Service

As any tourist knows, Rockefeller Center is a marvelous photographic locale. Usually, you're standing around the rim of the pit, shooting down at the skaters, the diners or other sights. This summer day, intent on capturing the golden statue of Poseidon from a low angle, I managed to get down into the pit before the restaurant opened. Each of the dining tables had a large furled umbrella. As I looked up, one of the umbrellas bisected Poseidon's forearm, making him resemble an old-fashioned waiter serving the table. (Not only that, a friend of mind added when first viewing the picture – it looks like he's carrying a Baked Alaska in his right hand!) I was only able to get the one shot, though – seconds later, the security guards unceremoniously hustled me out of there.

FACING PAGE

The U.N. complex near the East River offers some interesting photographic opportunities. I've had some good results in the handsome sculpture garden just north of the principal buildings. But the U.N. being what it is, there's a desire to convey some significance with the picture. I think this one does the job – spotlighting the mangled pistol, but with enough backdrop of flags and building facade to identify the locale.

Just a word on how the rest of this book is organized. Chapter 2 covers the surprising juxtapositions that reveal the incongruities of a city where so many seeming contradictions exist side by side. The emphasis in Chapter 3 is on the sights of the city – Times Square, Rockefeller Center, Fifth Avenue, Wall Street, and so on. Chapter 4 concentrates on the city's multifarious inhabitants. In Chapter 5, I've assembled some pictures that touch the emotions or tell a story. Chapter 6 contains my tips on photographing the city. And I conclude with a few personal notes.

So here we go, on a whirlwind tour of Manhattan with camera in hand, to record some of the infinite possibilities.

(Caption on facing page) **Modern-Day Plowshare**

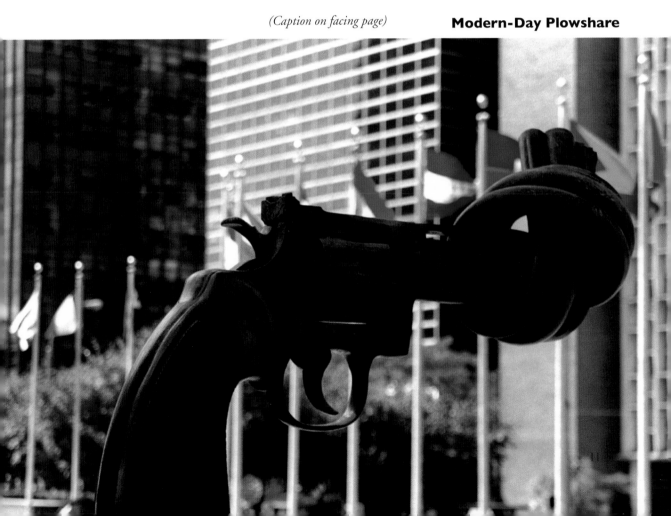

Metered Parking

(Captions on facing page)

Valet Parking

2 / Juxtapositions

Let's face it, New York is a jumble of a city in which innumerable disparate elements manage to co-exist. I find that many of my better images result when I've been able to juxtapose two (or more) of these seeming contradictions within a single frame.

The tone of this type of picture is often ironic – the offspring of an incongruous pairing. What makes it even more interesting is that the irony may not be readily visible at first glance – it doesn't always jump out at you. That's one reason why a camera – with its ability to record such fleeting scenes for posterity – is such a handy tool.

You can often sharpen the juxtaposition by cropping the pictures to eliminate distracting elements that dilute the message. That's true of photos generally, I might add – not just this type of shot. Since much of what's worthwhile pictorially fits better, within a linear composition, you'll notice that many of my pictures are veritable slices, as the book title indicates – longer and skinnier than you may be used to viewing.

FACING PAGE

Here's an episode (top) that took place right on my own street corner. I pass by this Starbucks every day – but on that day, a horse was parked at the meter! Those of you with a sharp eye will solve the mystery – that's a billy club pointing down from the saddle, and even New York's Finest need a coffee break now and then. (By the way, quite by accident, that's our adorable bichon, Lucy, down the street.) The real thrill for me was that I had my camera with me. Carry a little one around at all times – you never know what may be in store.

At the corner of 72nd street and Broadway (bottom), I happened upon the classic NYC juxtaposition – the white stretch limo and the papaya stand – with the liveried occupant undoubtedly standing in line for two of Gray's' storied hot dogs. I didn't want anything to interfere with the purity of the contrast – except for the befitting graffiti adorning the rear of the newsstand – so I positioned myself in the middle of the intersection and waited until the traffic whizzed by before taking the shot.

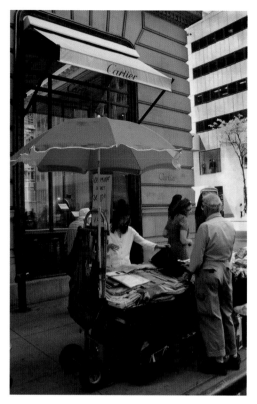

Pushcartier

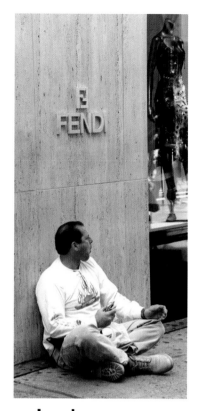

Lunchroom

(Captions on facing page)

Salvation Alley

Well-Bred Dogs

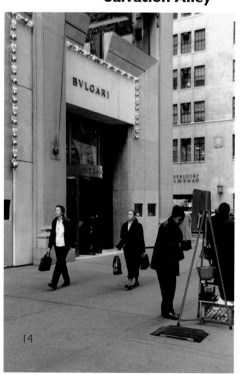

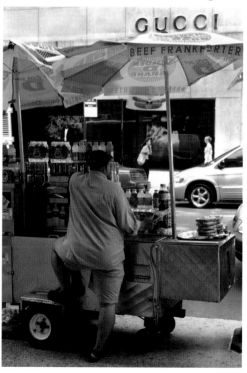

I'm always on the lookout for images that furnish a contrast to the plentiful signs bearing the names of well-known Big Apple merchants. These two pages contain five representative samples.

FACING PAGE

Some less expensive transactions are occurring on the curb outside one of the city's priciest jewelers (upper left) – symbolic of the highs and lows that operate all around town. I was struck by the incongruity of the sidewalk sandwich being munched in front of a fabled retailer (upper right). I couldn't help but notice the volunteers soliciting for the needy during a warm and snowless Christmas season (lower left), outside a spiffy Fifth Avenue house of gems, just south of the height of women's fashion on the next corner. And how about the city's hot dogs bearing a designer label (lower right) – with the frankfurter man poised in his at-the-ready stance, while taking in the sights across the way.

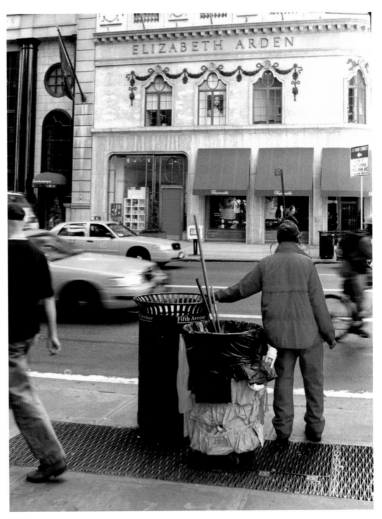

Fix-Up Clean-Up

Here, what caught my eye was the contrast between the garbage man in his bright red outfit – well, that's Fifth Avenue for you – and the fashionable salon across the street. I also like the sense of motion imparted by the passing taxi, bicyclist and pedestrian – well, that's New York for you – while the central figure stands stock still at his post.

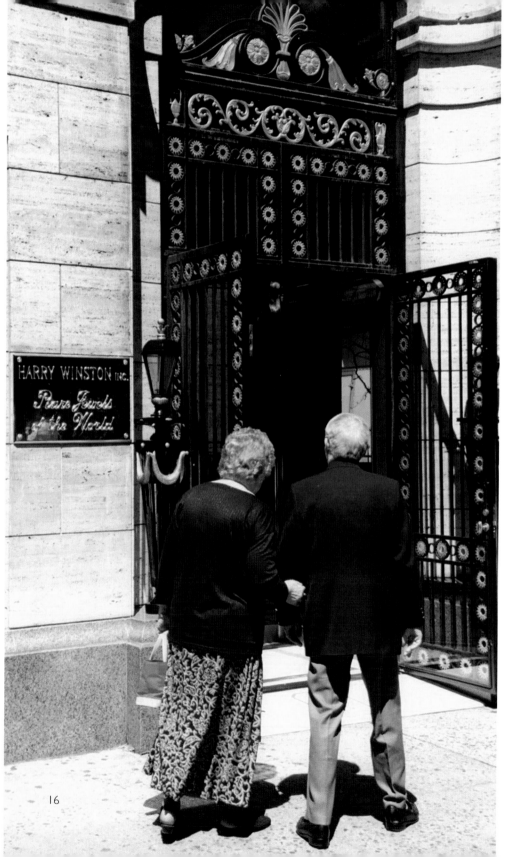

Golden Anniversary

One day, I waited in front of the ornate Harry Winston entrance for a while, not sure what the picture would be – perhaps a would-be burglar, or an obvious gold-digger. The older couple about to make the big plunge – although more satisfying than ironic – proved ideal.

Art of the First City

What struck me here (right) was the juxtaposition between the banner on the Metropolitan Museum touting its current offering, "Art of the First Cities," and what was passing for art on the chalked pavement of what we consider the world's "first city" today. Or forget about cities — these gutter hieroglyphics may be thought to constitute our present-day version of what was once produced by prehistoric cave-dwellers.

You can't tell for sure, but this woman (below) was getting into *the taxi. So, to me, the image suggested her leaving the grungy world of the subway — note the pile of litter under the sign — and beseeching the cabdriver to whisk her away from all that disorder. On the other hand, if she were getting* out *of the taxi, then the analysis would probably focus on the mess she's about to descend into.*

Modes of Transportation

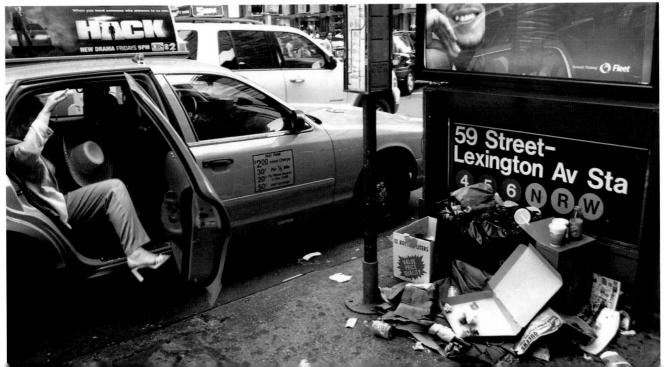

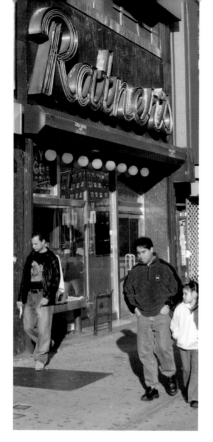

The Passing Scene

A painful sign of the times can be a first cousin to the juxtapositions. A case in point is Ratner's (left), once a culinary mainstay of the Lower East Side, but now a victim of cultural changes in the neighborhood and forced to close its doors (below).

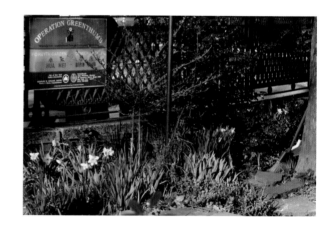

No one would consider the Lower East Side a garden spot, but the Operation Greenthumb in its midst (right) represents a start – as does the adjacent soccer field (below).

Two Patches of Green

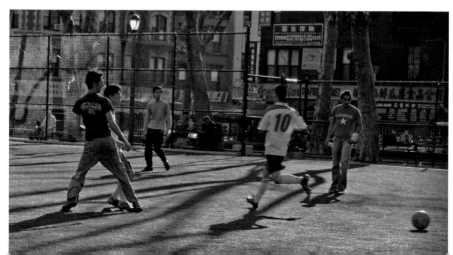

18

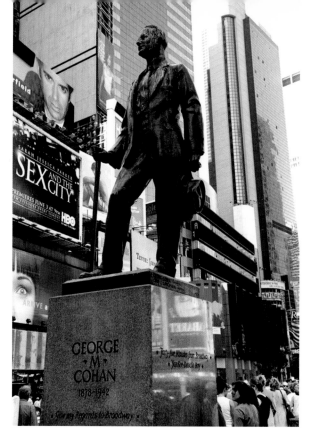

There's no area of the city where the juxtapositions are as vivid as around Times Square. For example, the statue of George M. Cohan – on 46th Street where Broadway and Seventh Avenue merge – is ideal to use as commentary on the contrast between then and now. I shot it various ways, but liked these two views the best. The picture on the left contrasts Cohan's Tin Pan Alley turn-of-the-century purity with the turn-of-the-millennium racy TV show advertised on the giant billboard. Then I moved around and got the other exposure below – Georgie boy (plus some pigeons perched on his shoulder) pitted against a billboard advertising "Les Miz" and "Phantom of the Opera". These are pretty good shows, but after all, Cohan was the real Broadway legend, and they're just relative upstarts.

Yankee Doodle Dandy

The Real Thing

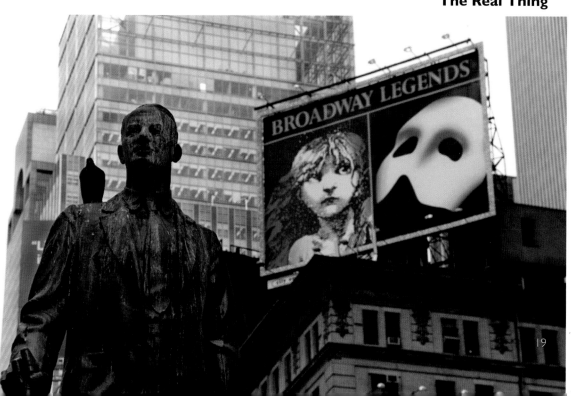

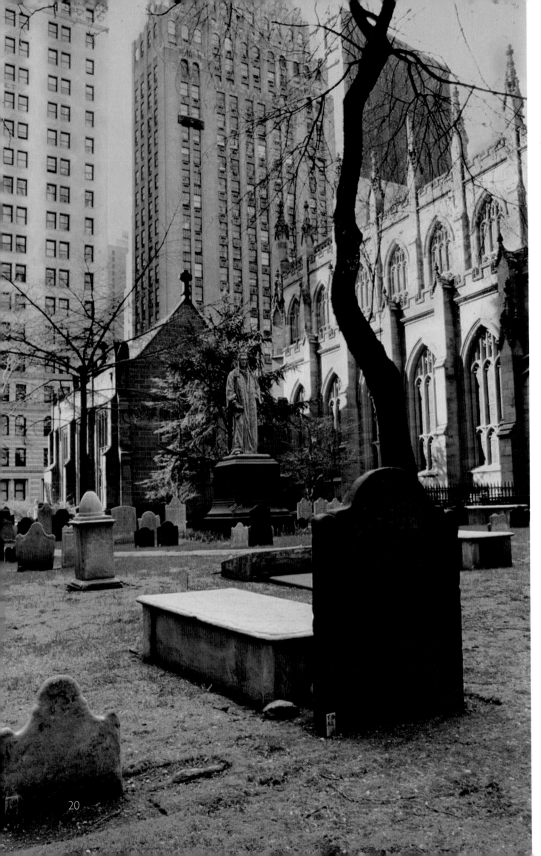

Real estate values in a prime Manhattan area like Wall Street being what they are, it's quite extraordinary to come upon an old cemetery off lower Broadway adjoining Trinity Church. Framed by skyscrapers, this serene setting offers the eye a place to rest. But even more to the point, in a city which relentlessly rebuilds itself and celebrates the most faddish of fashions, the cemetery's link to the past provides the mind with an opportunity to meditate on the transience of fame and fortune.

Highest and Best Use

3 / Sights of the City

If there were no interesting people in Manhattan, a myriad of photo opportunities would still abound. There are just so many sights, many not duplicatable anywhere else. This chapter explores some of the city's prime vistas – from the grandeur of Rockefeller Center to the beauty of Central Park to the incongruity of an icebound yacht basin. You can pass by sights like these every day as you travel around town without realizing the photographic possibilities they offer.

In a Mist

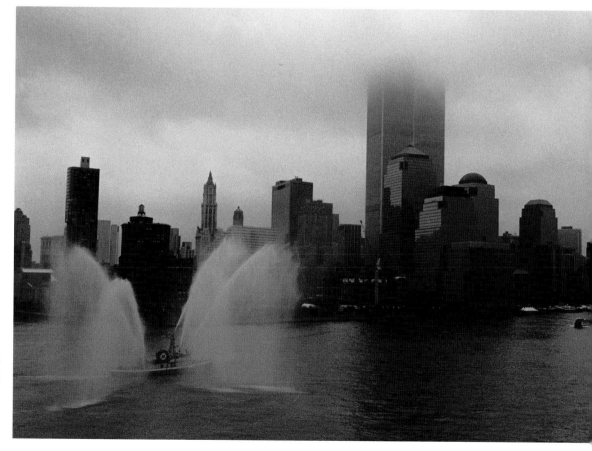

When I took my mother on a cruise some years ago, we departed New York on a rainy day. At the time, I had no idea that any symbolic significance might attach to the fog-shrouded tops of the World Trade Center towers.

If there's one single place to start photographing the sights of Manhattan, it would probably be Rockefeller Center. There are so many facets of its attraction, and the scene changes with the season. The next four pages contain a few typical images; others can be found throughout the book.

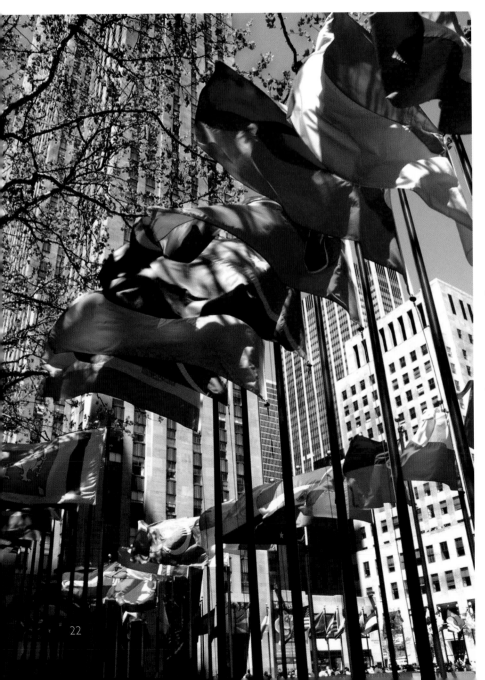

Northeast Breeze

The multiple flags of Rockefeller Center are a real trademark. If you're lucky enough to be there in the spring when the first buds peek out from the trees amid brisk winds, you can get a picture like this.

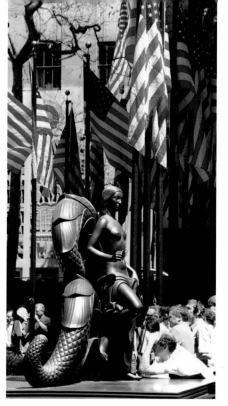

This statuesque maiden (left) – juxtaposed against the once-a-year display of American flags – guards the rink entrance, totally ignored by tourists who are fixated on something else.

One day I looked up (right) and spotted something a little different (but understandable) among the pennants.

The toy soldier (below left) and his comrades are a fixture of the Christmas scene.

This memorable DeSoto grille (below right) was in an artistic display of a dozen vintage cars – one of the special exhibits the Center hosts periodically.

Patriotic Sunbathers

Tree Surgeon

Rat-a-tat

Car of the Year

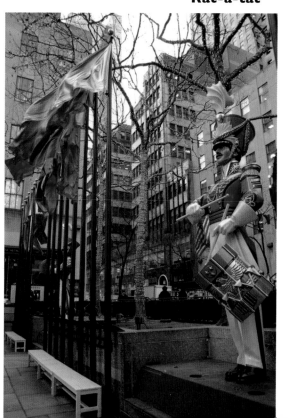

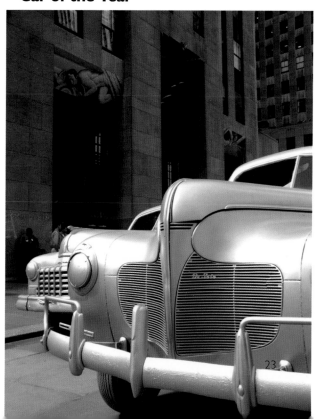

23

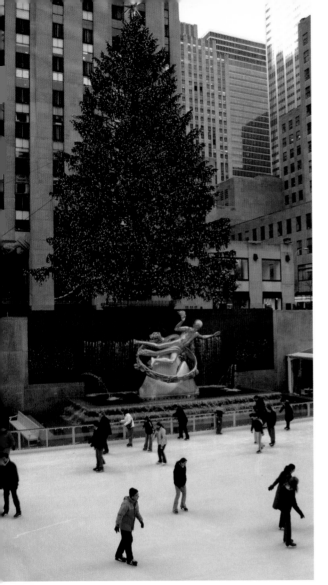

FACING PAGE

East of the rink, heading toward Saks on Fifth Avenue, are the marvelous Christmas-time angels. I have a special interest in these, because my parents' company was responsible for the original creation of the angels many years ago (see "On a Personal Note").

Single Lutz

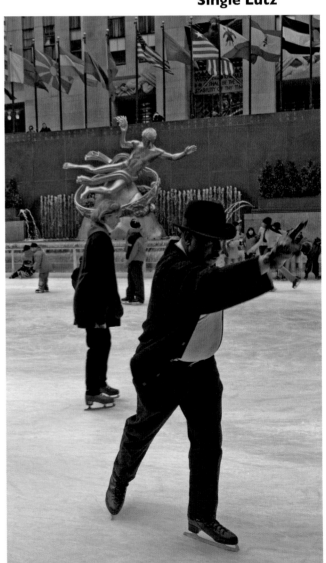

O Tannenbaum

The most memorable time of year in Rockefeller Center is the Christmas season. The huge lighted tree which hovers over the skating rink (above) is an annual trademark. And the skaters can put on quite a show — often in imitation of Poseidon's classic pose (right).

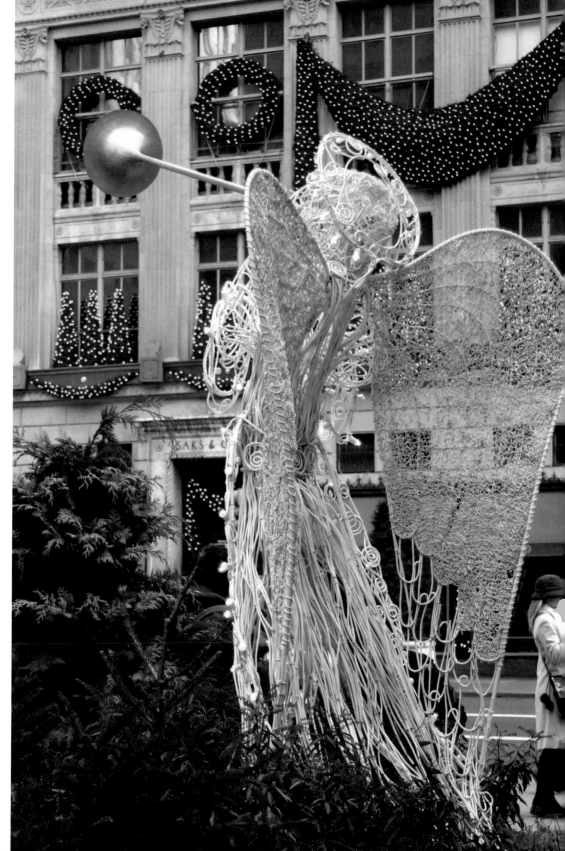

(Caption on facing page)

Angelic Host

Another fine photographic venue is Lincoln Center, with its white marble buildings, fountain and reflecting pool. It's seldom crowded during daytime hours, and you get a sense of peace and tranquility, especially near the fountain or pool.

The structures of Lincoln Center inspire awe but the water is what makes it all come together. This fountain links the trio of musical auditoriums.

H₂O

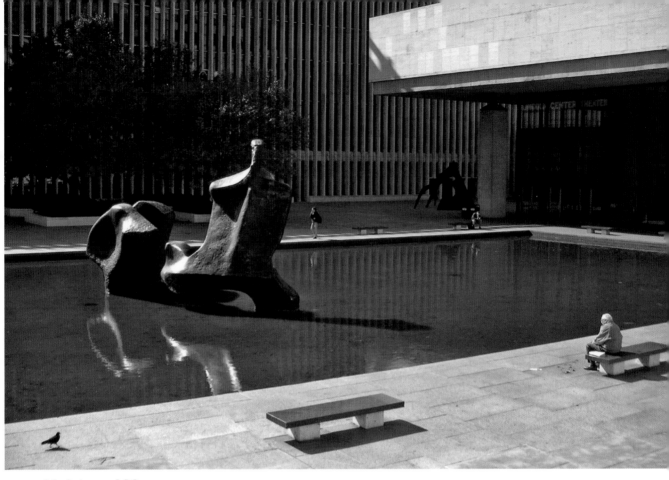

Moistened Moore

The reflecting pool (above), with the massive Henry Moore sculpture, inspires quiet moments for both man and bird. Things just weren't the same, though, when New York's water supply ran low a few years ago (right).

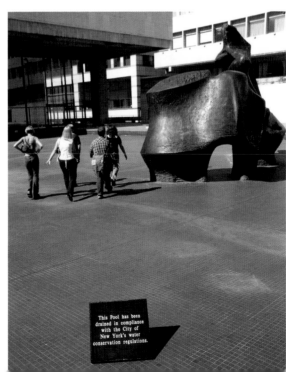

Drought

This Pool has been drained in compliance with the City of New York's water conservation regulations.

Wonderful statuary abounds in New York City, often taking on iconic proportions over the years. For a photographer, it makes sense to home in on this bounty in order to devise some offbeat images.

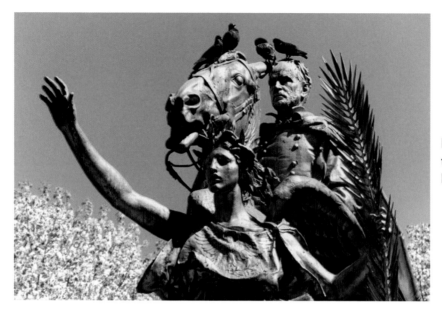

**Ruling
the
Roost**

*(Captions
on
facing
page)*

**Leo
and the
Pigeons**

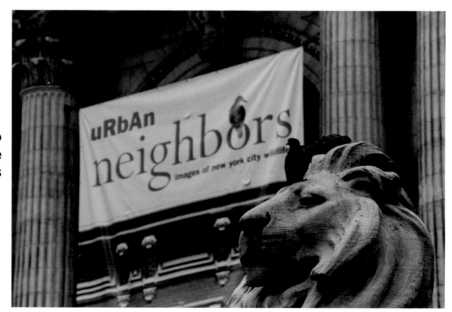

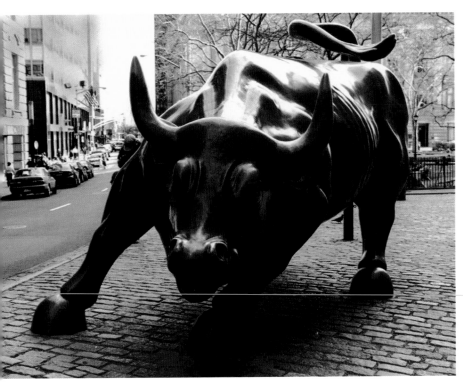

There's a massive bull near Bowling Green, symbolizing the adjacent Wall Street area. I couldn't resist shooting the creature both ways – first head-on looking south and then circling behind it to face north. In the exhibit, I placed the images side-by-side to provide the full picture – and, by extrapolation, a commentary on the vagaries of the stock market.

The Beginning – and End – of the Bull Market

FACING PAGE

In this city, wherever there are statues, there must be pigeons. One bright day at Grand Army Plaza, I shot General Grant from all angles and at different focal lengths. The picture I liked best was this close-up (top), featuring the pigeons – and conveying the message that such is the price of fame in Manhattan.

Passing by the 42nd Street Public Library one day (bottom), my eye was first drawn to the "Urban Neighbors" banner promoting an exhibit on New York wildlife, then to the massive stone lion, and then to the ubiquitous pigeons. Life was imitating art, with Leo and the pigeons emerging as the true urban neighbors.

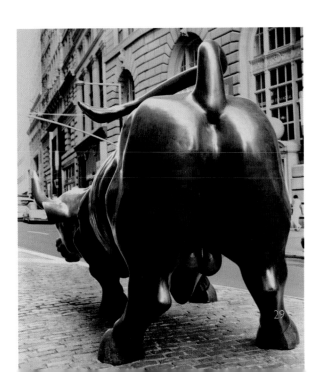

In attempting to capture the look of the city, don't ignore billboards and store windows, which may offer up some tasty treats.

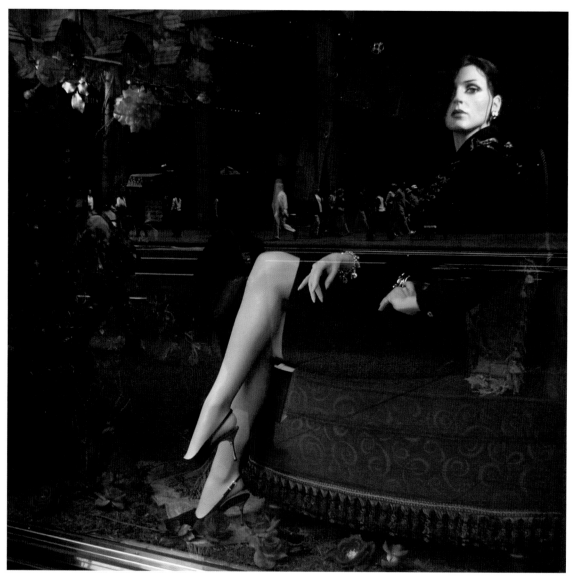

Window Shopping

Shooting into a store window can be tricky business – the reflections often mar what you're trying to capture. On this one, though – featuring a posh mannequin gazing coolly across Fifth Avenue – things worked out all right.

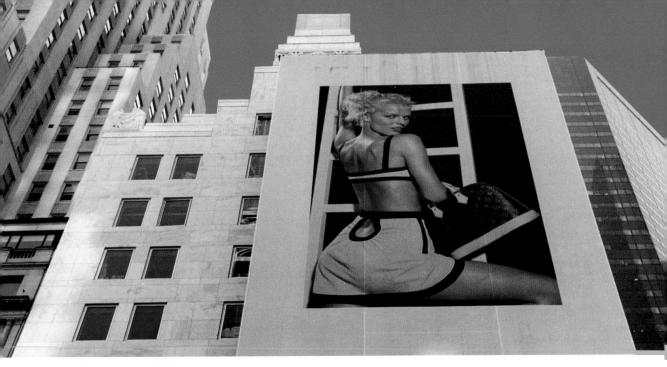

Sure Beats Graffiti

Knowledgeable shoppers will be able to tell from the handbag that the enlarged beauty above is advertising Louis Vuitton. But I decided to crop out the label appearing below the lady and portray her as a symbolic force of nature, holding her own against the surrounding skyscrapers.

Wait 'Til Next Year

This huge image of Knick legend Patrick Ewing loomed above "his town" on a West Side building exterior. The location wasn't far from Madison Square Garden — where, after all those alternately exhilarating and painful years, the league title was never quite forthcoming. . . .

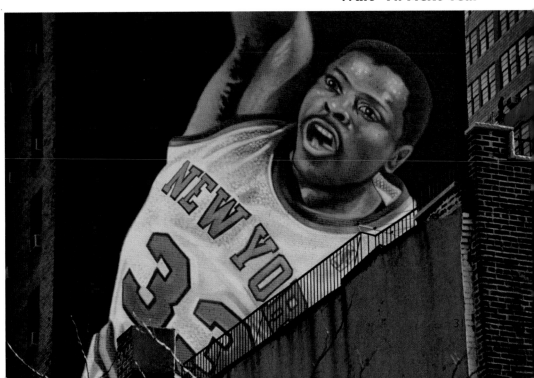

37

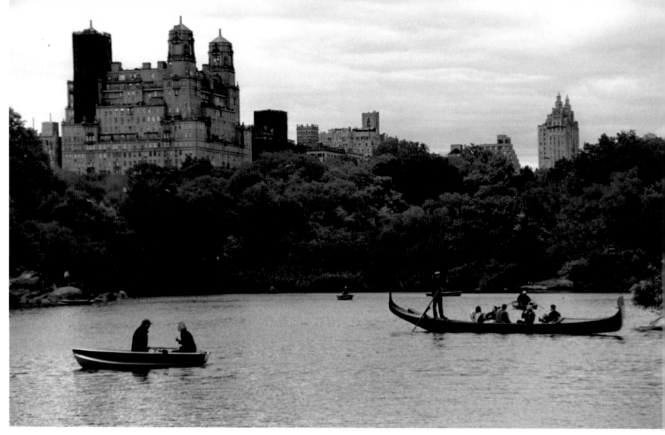

Palazzo Beresford

Venetian Rules of the Road

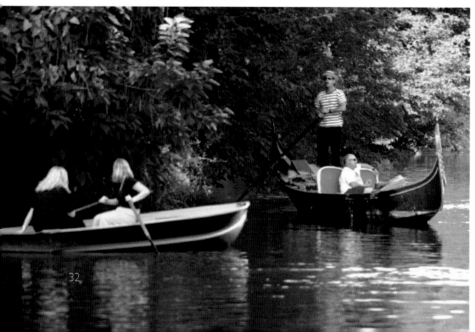

The concept of a gondola being poled in the middle of Manhattan may seem out of place, but it does offer some unique photographic opportunities. I envisage the massive apartment building on Central Park West (above) as New York's version of a Venetian palace. And here's my version of the dialogue taking place in the scene at the left – the gondolier yelling at the rowboat oarswoman, "Hey, watch out, signorina, I've got the right of way!"

My favorite venue to photograph in New York City – and perhaps anywhere – is Central Park. In fact, I devoted a previous book to just this subject – *CENTRAL PARK – A Photographic Excursion* (Fordham University Press, 2001). The breadth of possibilities – the trees, rocks, waterways and artifacts – is enormous. What's more, New York's seasonal changes can be better appreciated in the Park than almost anywhere else. And even beyond the physical attractions of the Park are the scores of people engaged in interesting activities (some of whom you'll meet in the next chapter). So grab a camera and – whatever the time of year – get out there immediately!

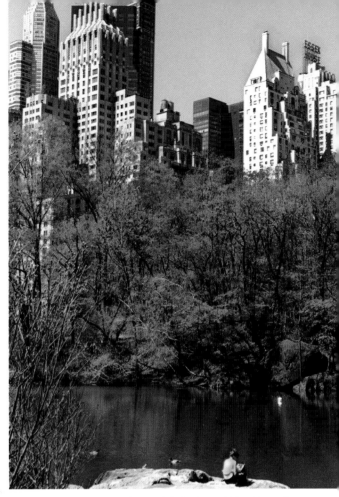

Little Fish in a Big Pond

Double Take

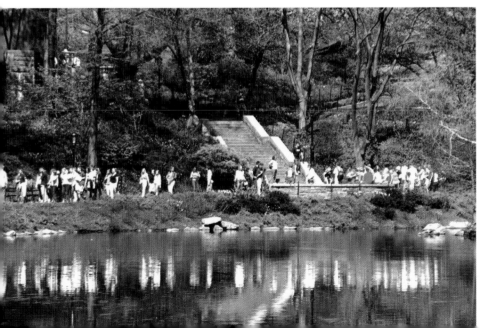

These two pictures were both taken near the southeast corner of the Park. In the wide angle shot (above), I was impressed by the contrast between the tiny foreground figure and the huge skyscrapers looming over the water and trees. Then I switched my zoom lens to telescopic in order to capture the reflection of springtime strollers in the pond (left).

33

This color
palette
from the
Thanksgiving
Day parade
was taken
from a high
vantage point
on Central
Park West.
The giant
balloon
animations
may draw the
oohs and aahs,
but there are
an abundance
of individual
marchers who
serve to
humanize
the parade.

**Rainbow
Connection**

34

For a Manhattan photographer, Macy's annual Thanksgiving Day parade can't be ignored. The shots available depend on your vantage point. Two of the best I've found are, first, high up in a Central Park West apartment with windows that open, shooting down on the parade (but this requires a friend in residence); and second, in the Park, facing west with the morning sun behind you and the CPW apartment buildings framing the massive balloons. It's almost impossible to get a good view of the parade from ground level on the west side of Central Park West (where big crowds form before 8 a.m. and just get worse as step-off time nears); and the east side of the avenue is strictly reserved seating. So, my advice is to enter the Park itself (for which you need to go up to 86th street and then walk south).

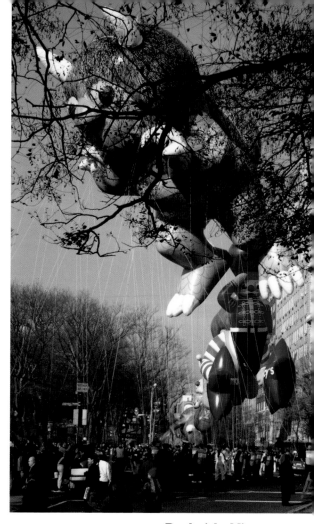

Parkside View

From the Park, you can't see the marchers, but you can hear the bands, and there's a terrific view of the balloons framed by trees and/or spectators. You can also move around to find different vantage points, as shown on this page – the shot above taken from 81st street, the one on the left from 73rd street.

Green Goods

35

Here Comes Spiderman

From a CPW window, using a zoom lens, I was able to capture the expectant expressions of youthful onlookers (left) – although it's the police officer's shadow that makes the composition.

Once, as I approached Central Park West on a side street with the parade well underway, the crowd was twenty deep. So, all I could see (below) was the posterior of a large dog from an unusual angle.

In photographing the parade with all its vivid colors, don't ignore the patterned possibilities available in black and white – especially when taken from a high vantage point (facing page).

Paw Prints

**76
Trombones**

*(Caption
on
facing
page)*

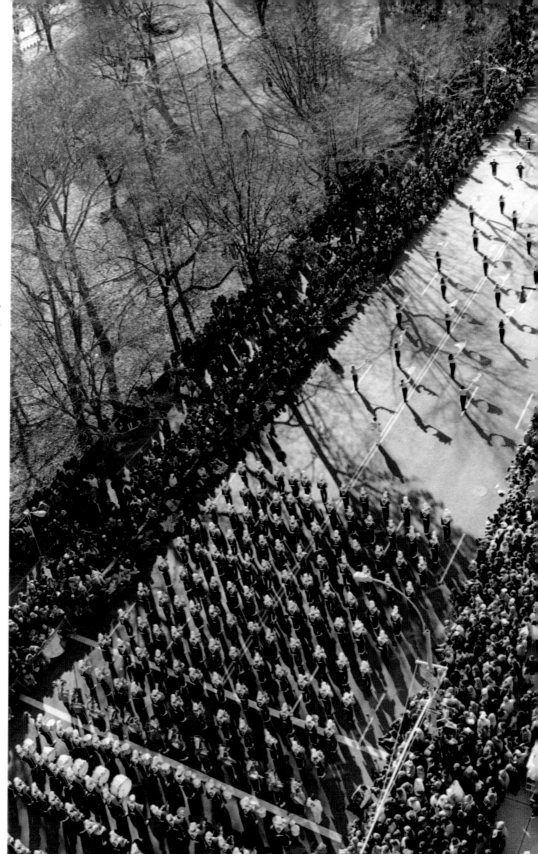

Manhattan Mandarin

Manhattan's Chinatown offers a number of photographic opportunities, from this evocative statue in Chatham Square (left) to the colorfully decked-out gift shops (below left) and the store window ducklings (below right). As the facing page shows, Chinatown has expanded geographically over the years, to the outposts of Little Italy (top) and to what's left of the Jewish presence on the Lower East Side (middle) – at times colliding with the growing Latino population in the area (bottom).

Dinner

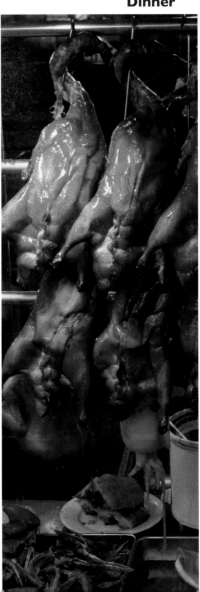

Made in China

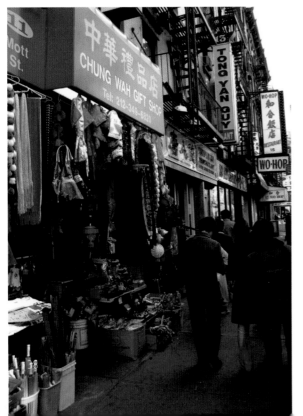

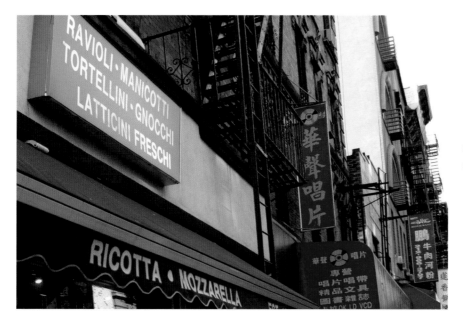

Contending Carbohydrates

Chinoise Chemises

(Captions on facing page)

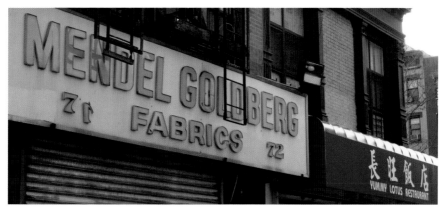

Cultural Compromise

Hudson River Flight Deck

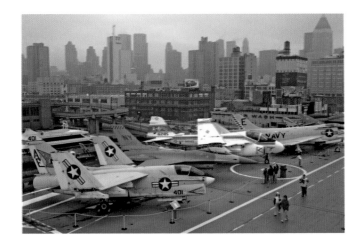

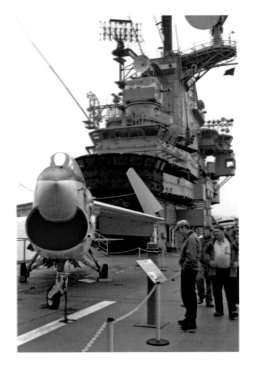

The Intrepid, a World War II aircraft carrier permanently berthed at 45th Street on the Hudson River, has been converted into a museum that's well worth visiting – not only for veterans (top left) but also for the younger generation (bottom left). In the view from the bridge (bottom right), the classic warplanes are juxtaposed against the city skyline (top right).

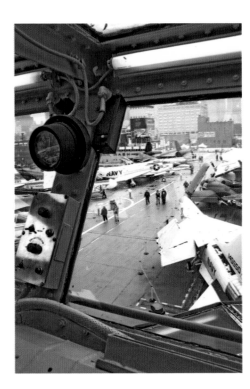

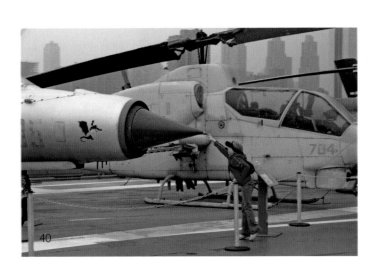

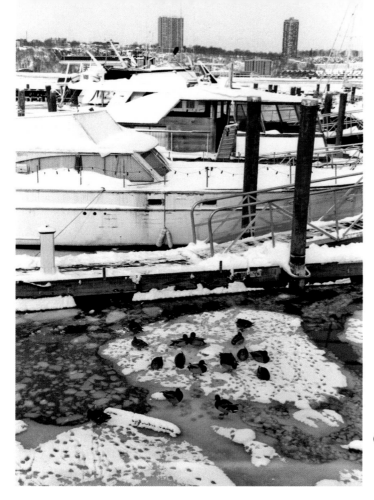

Savvy New York photographers never forget that Manhattan is an island and take some of their best pictures of the surrounding waters and what's in them. It's not just about ferryboats, tugs, cargo vessels and ocean liners – at 79th Street, we have our own Hudson River yacht basin. Most people photograph the yacht basin during the spring and summer. But when the Hudson River freezes over, the stranded boats and their maritime companions – of the duck (left) and gull (below) variety – produce some interesting images.

Cold Duck

Beached Gulls

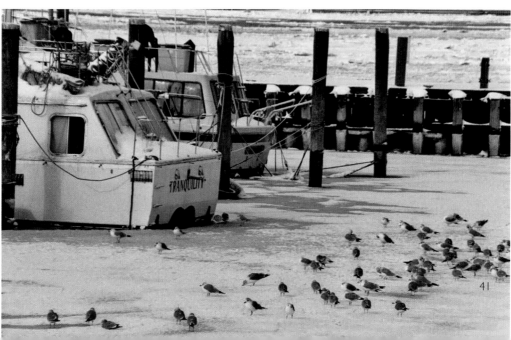

The Paris-Rio Axis

Here's an example (above) of downtown semi-alfresco international dining. Good graffiti can take on the mantle of high art, as displayed in this Upper West Side setting (below).

Schoolyard Mural

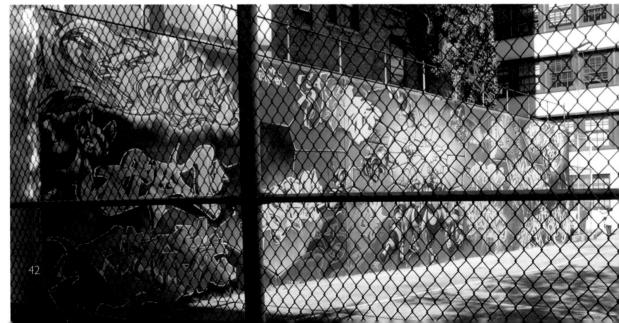

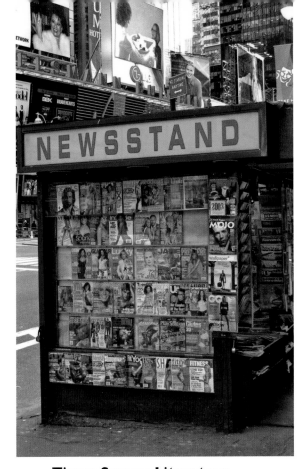

Times Square Literature

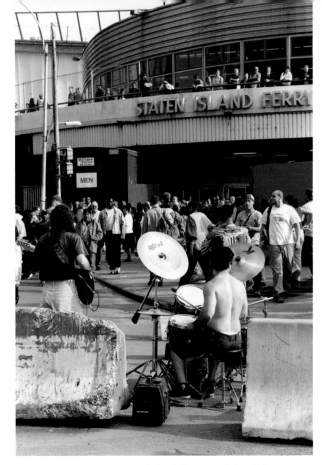

Post-9/11 Dockside Gig

Low Overhead

There's a host of reading material to be had on the streets of New York – if not from one of the city's ubiquitous newsstands (above left), then from the many sidewalk vendors of used books (right). The informally clad band (above right) is performing at the Manhattan entrance to the Staten Island Ferry, where the concrete barrier provides a grim symbol of augmented security in the wake of 9/11.

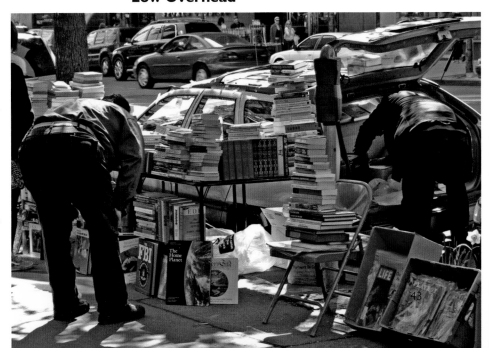

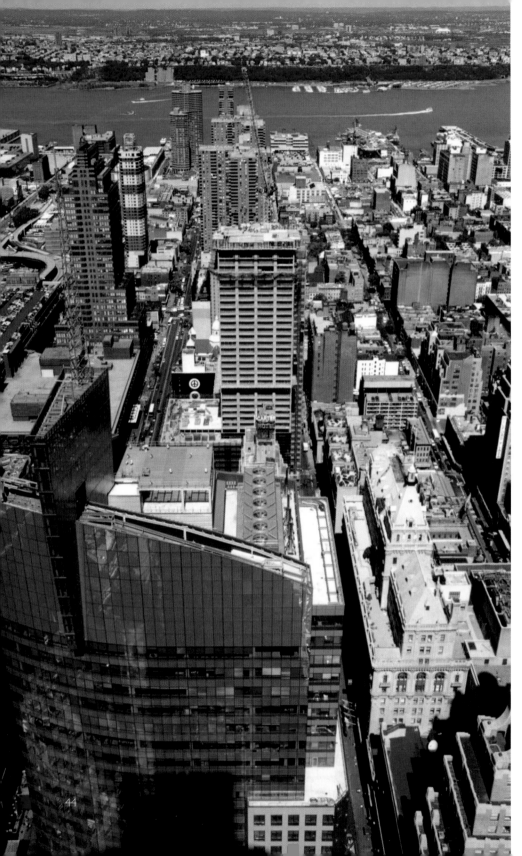

Some of my favorite cityscapes have been taken from high up. Try to gain access to a tall rooftop, especially where the view extends in several directions. The Empire State Building is well worth a photographic visit. An open window on a high floor can be fine, but most of the windows in newer buildings won't open, so you're forced to shoot through the glass.

Westward Ho!

(Caption on facing page)

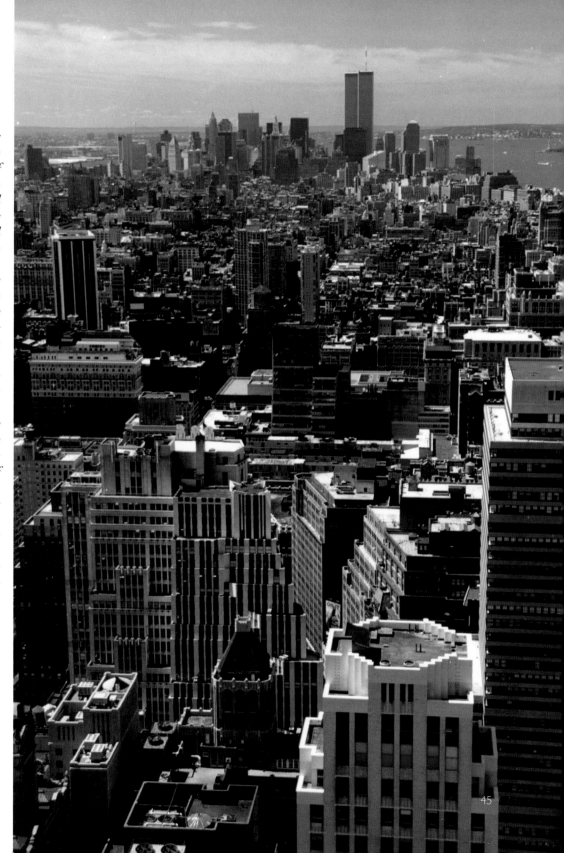

Here are two overviews of Manhattan snapped from the roof of a tall building in Times Square. Many of the pictures on subsequent pages were taken from this location. The view south (right) dates from the summer of 2001 – just before the tragedy of September 11. The view west (facing page) extends across the Hudson River to the New Jersey shoreline.

Ante-Bellum South

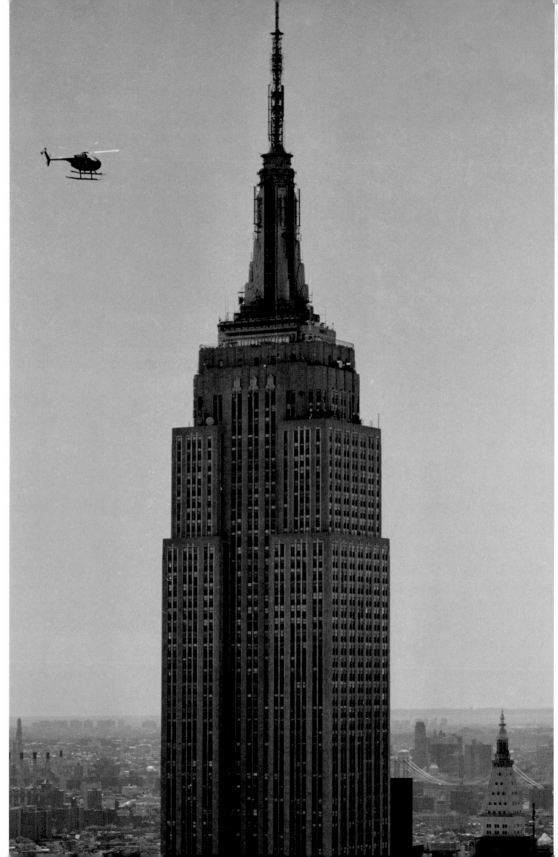

When you're up high, once you've finished shooting several overviews of the broad urban vistas (as on the preceding two pages), it makes sense to turn your attention to individual buildings. Here, I zoomed in on the best-known of them all – the Empire State Building – and was fortunate enough to do so just as a helicopter buzzed by to survey the scene. Note how the ESB's height is enhanced by the way it dwarfs the otherwise tall tower at the lower right.

The Monolith and the Gnat

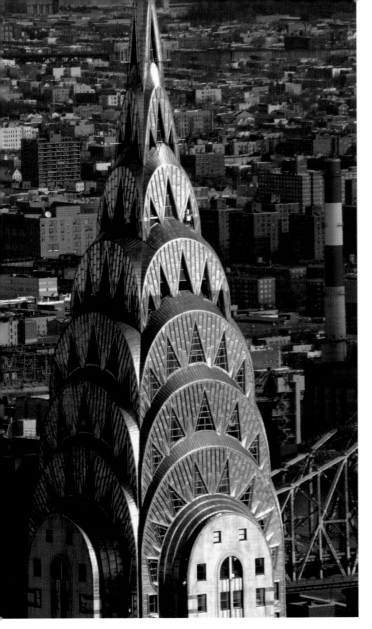

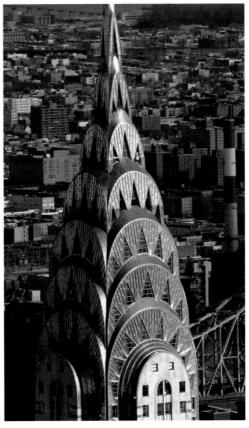

Art Deco Obelisk

One of the notable benefits of the digital revolution (see Chapter 6) is the computer's ability to convert a color photo into black & white with just the click of a mouse. From the observation deck of the Empire State Building, I took this color picture (above left) of what is arguably Manhattan's most attractive edifice, the Chrysler Building. Then I made a black & white equivalent (above right). Which photo is preferable? It's strictly a matter of individual taste. The color version has more verve to it, including the red-and-white smokestack (which may appeal to some people and not to others). The black & white rendering, while quieter, conveys more of a retrospective quality, harking back to the building's heyday in the '30's.

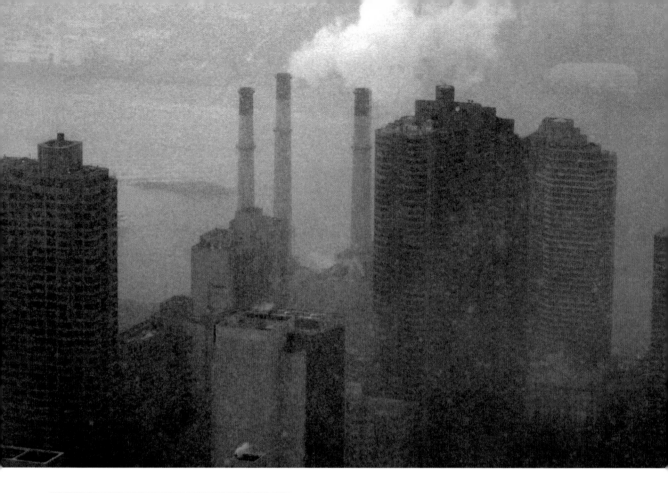

Smokestacks in the Living Room

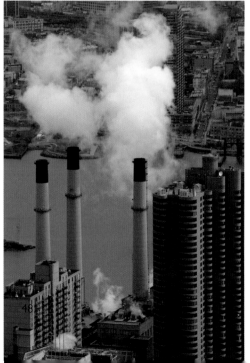

When you're high atop the Empire State Building, the weather can change dramatically in a matter of minutes. The hazy horizontal view of apartment houses and smokestacks looking east (top) was taken on a winter day through a thick cold fog that enveloped us. (This was originally shot in color, but the scene had a lot more character in black & white.) Within the hour, the sun appeared (left), and the same view (now composed vertically for maximum impact) became quite crisp. As a matter of fact, given the highlights and shadows and the East River backdrop, it now looks even more dramatic in color (facing page).

48

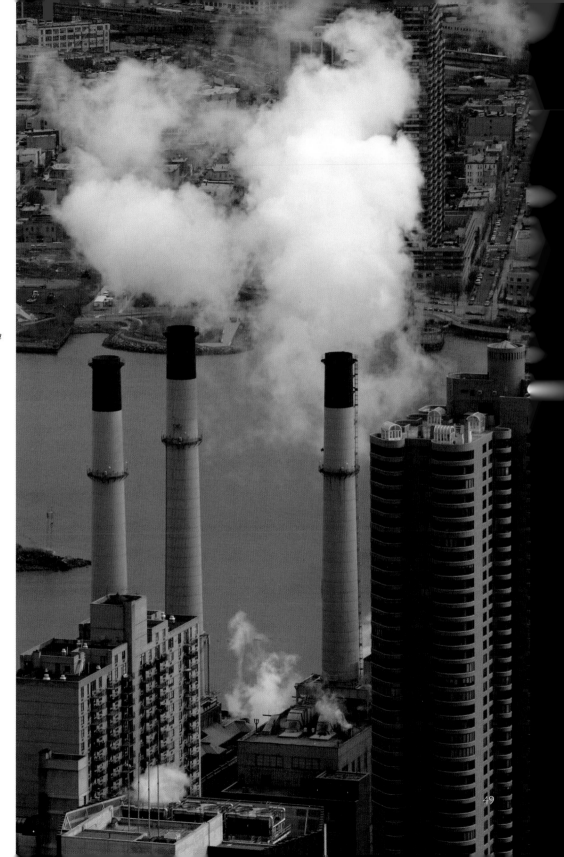

(Caption on facing page)

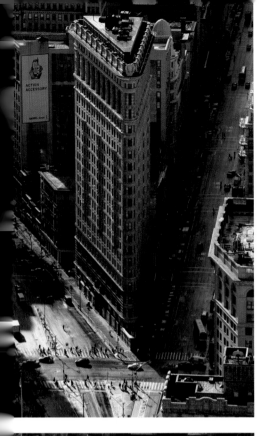

Digital imaging and the computer now offer the photographer a third click-of-the-mouse alternative. This shot of the landmark Flatiron Building looks fine in color (top), but I find the yellow sign on the left of the composition jarring. It's not difficult to remove the yellow digitally (bottom left), but this bothers me in terms of photographic integrity. Black & white (below) does away with the problem. For this shot, however, my favorite mode is sepia (facing page), which gives Manhattan's turn-of-the-century masterpiece structure an appropriate archival feeling.

Perennial Triangle

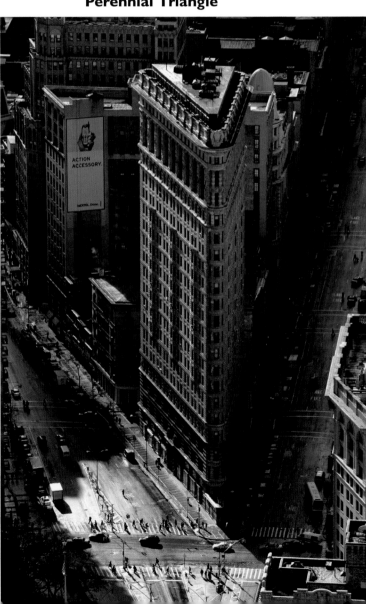

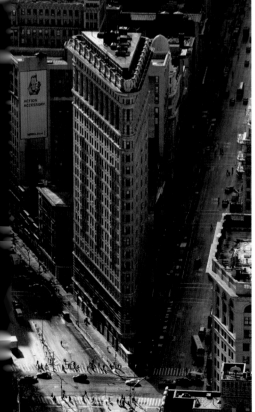

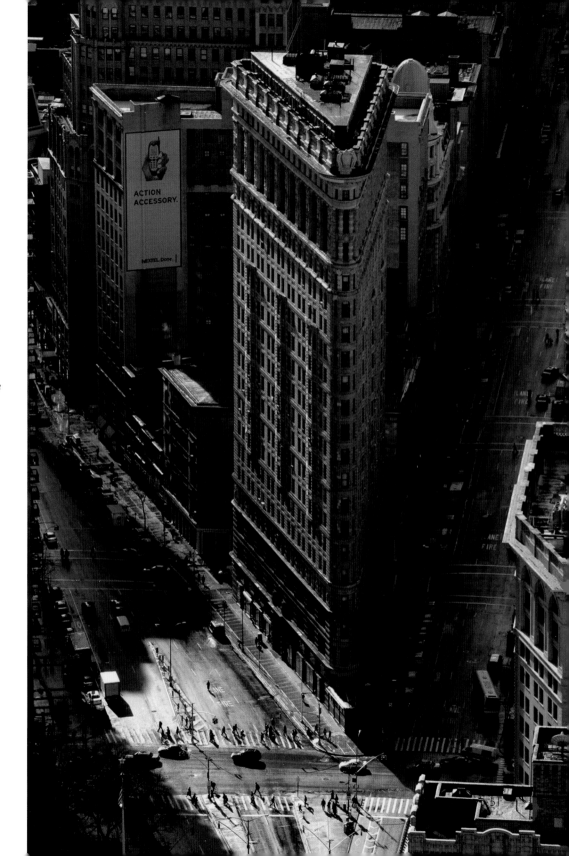

(See caption on facing page.)

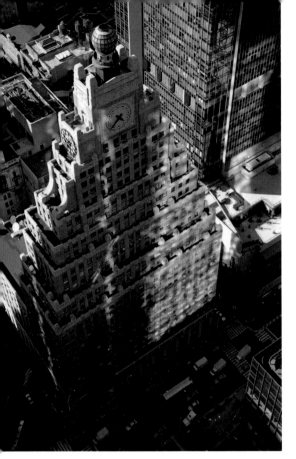

When you're high up, make sure you have the ability to shoot in both wide angle and telescopic formats. (A zoom lens is the simplest way to achieve this.) Then take the same good scene both ways, homing in on the most significant element with your zoom. The wide angle gives context and scope – the telescopic provides character and definition.

Serious Setbacks

This noteworthy building in Times Square (above) – which used to house the fabled Paramount Theatre – has great lines, featuring a series of artfully designed setbacks. The wide angle view takes it all in. But the building's crowning glory is its clock and topping structure (right) – not so visible from the street – which is best appreciated in close-up.

Pigeon Timepiece

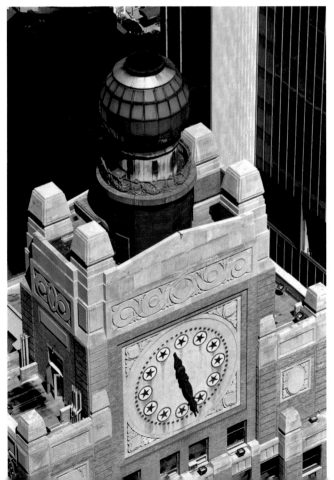

52

Library at Large

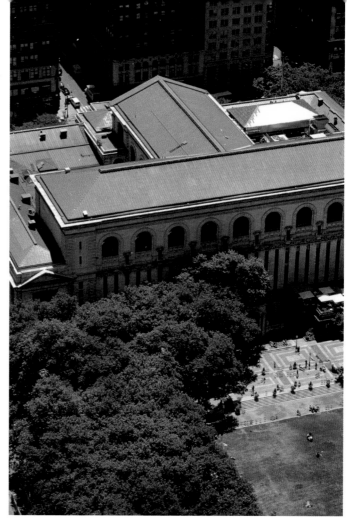

This is a wide angle view (right) of the 42nd Street Public Library, the terrace adorning the rear of the building, and the northeast corner of Bryant Park. Now that we know where we are, we can shoot a close-up (below) that captures the patterns of the terrace, its tables and chairs, and a few of the occupants.

Public Terrace

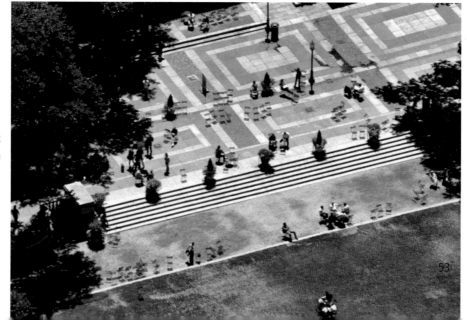

53

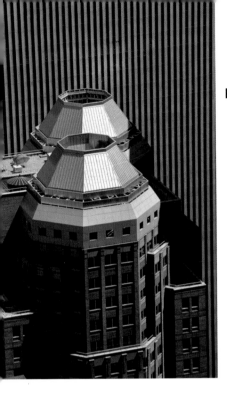

Matching Octagons

One of the advantages of being up high is the ability to spot patterns which make for interesting photo compositions – such as the twin octagonal openings framed against the vertical lines of the background structure (left). You can capture a pleasing design like the one below if you visit the Empire State Building after a snowstorm and point your zoom lens in the direction of Peter Cooper Village and Stuyvesant Town. One of the lesser-known gems in the city is the Art Deco design of the building on the facing page.

Rooftop Mosaic

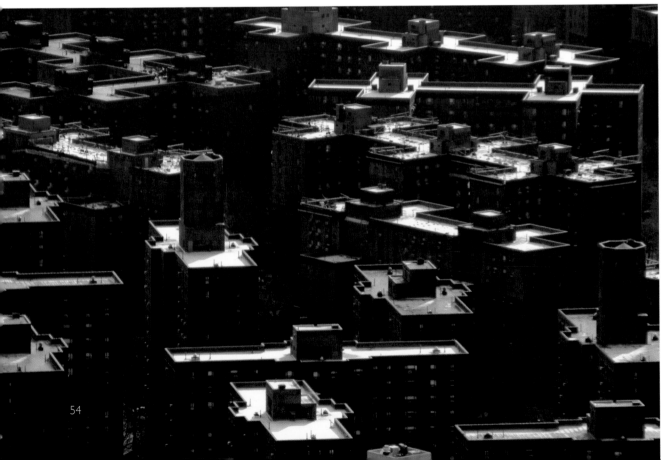

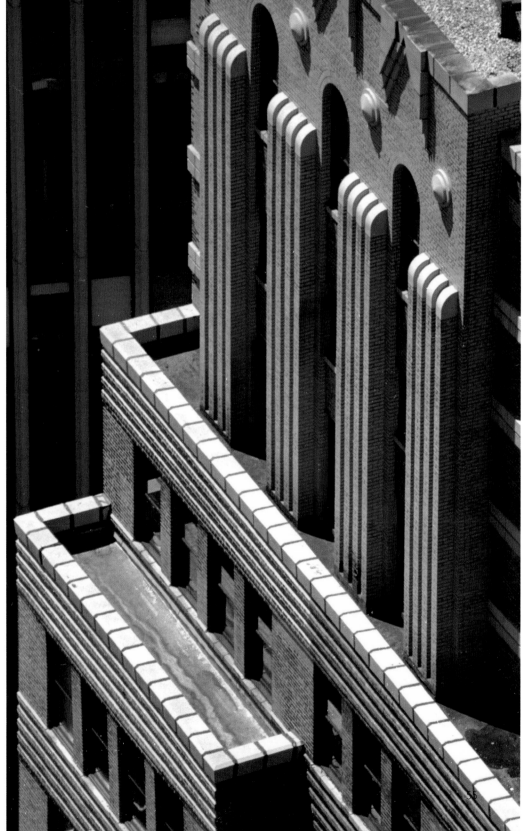

(Caption on facing page)

Acute Angles

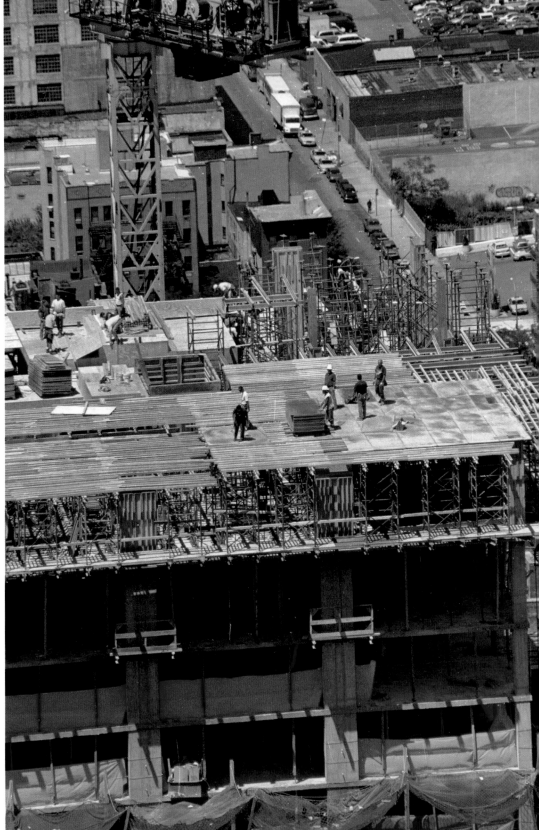

Lofty Workplace

One disadvantage of shooting from up on high is that you don't see too many people. So when I spotted these workers on a nearby construction site, I zoomed in – but not all the way, so as to leave the context of the unfinished building and the street below still visible.

56

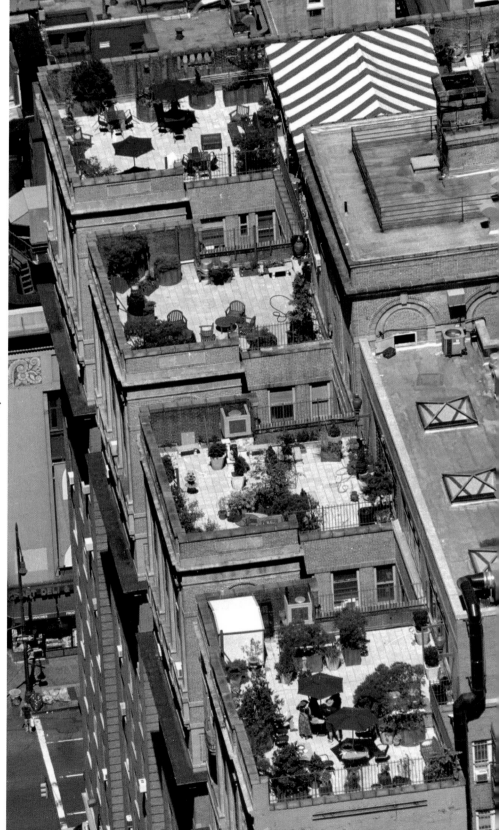

An advantage of being high up is that it gives you a peephole into some otherwise private living quarters. I was struck by the symmetry of these tidy rooftop terraces, perched above a busy commercial thoroughfare (visible at the lower left).

Petite Penthouses

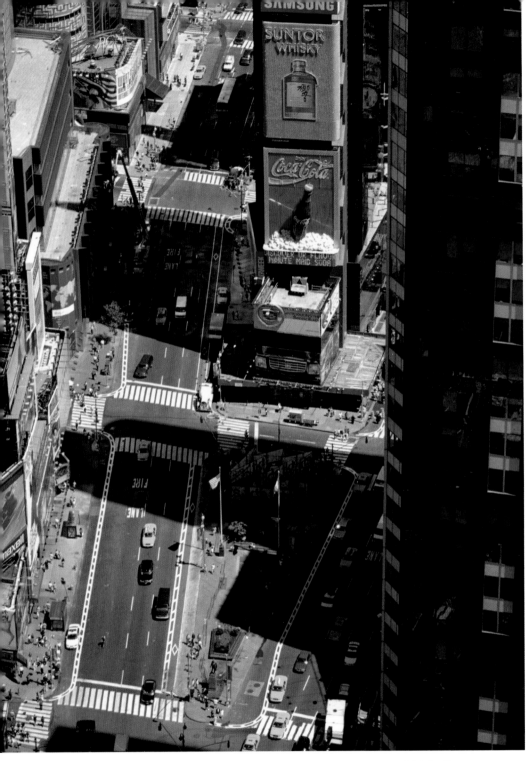

Unless you suffer from acrophobia, try to lean out a little ways over the wall of the roof in order to take some pictures looking almost straight down – an angle which can provide some striking vistas.

Here's a wide angle view of the upper end of Times Square and of Broadway heading north.

The Union of Broadway and 7th Avenue

Fright Of Hand

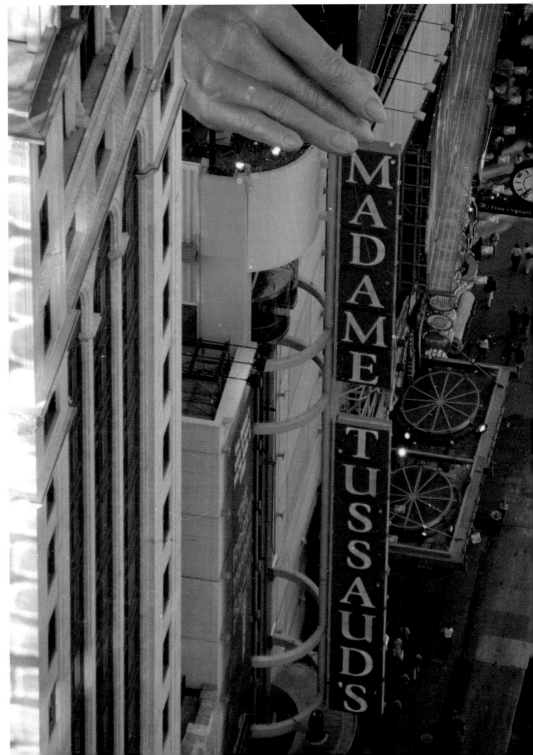

This is a closeup of the sign outside Madam Tussaud's 42nd Street waxworks. It's the eerie fingers that get to me.

Coffee Break

If you can manage to position yourself at an angle that faces directly up or down an avenue – as with this shot of Avenue of the Americas looking south (left) – then think about cropping it into a strip like this to emphasize the linearity. More traditional approaches can be seen in the head-on shot (above) or the diagonal composition (below), which maintain plenty of vitality.

FACING PAGE

Even the most ordinary sights take on a fresh dimension when viewed from a different perspective than the one we're used to. In order to take the picture on the facing page, I leaned out of an open building window and shot almost straight down – trying to breathe new life into a busy intersection.

**Sixth
Avenue
Sliver**

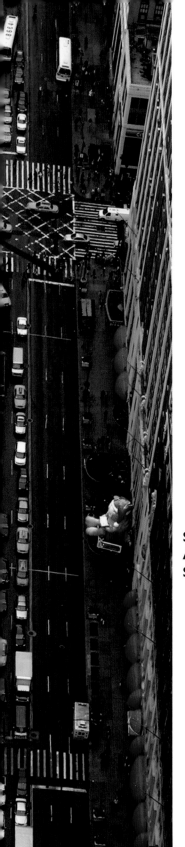

Miracle on 34th Street

**Eye
in the
Sky**

*(Caption
on
facing
page)*

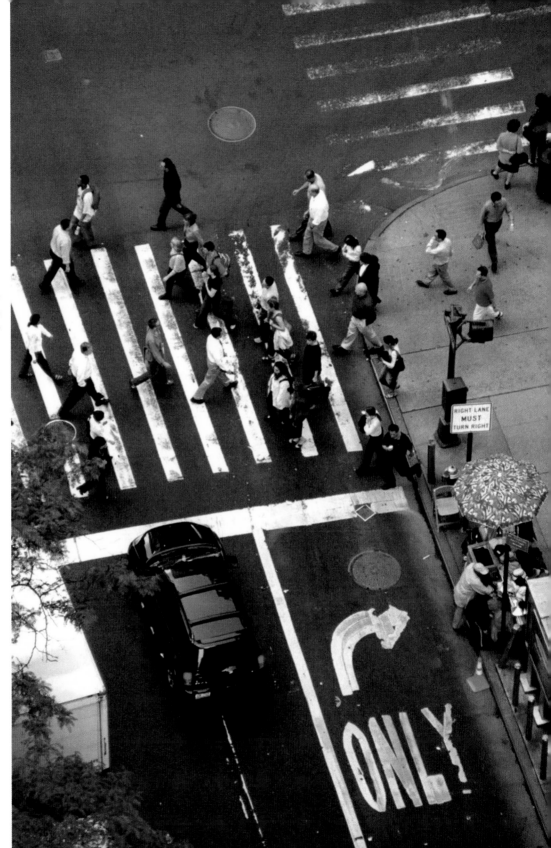

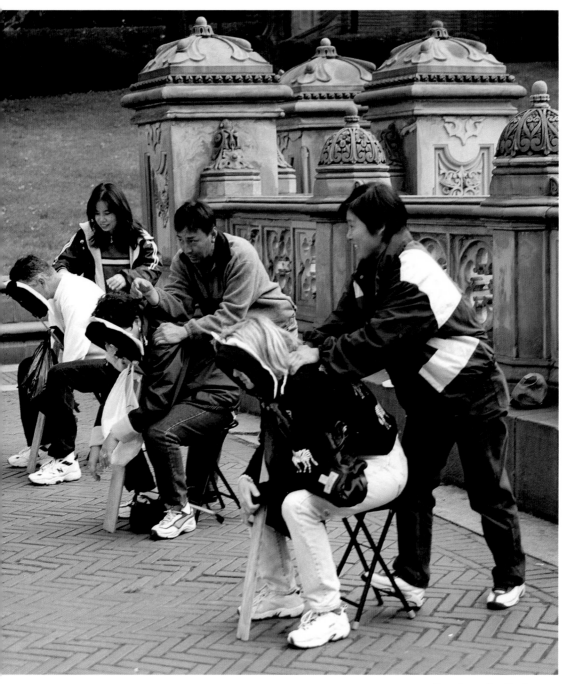

Bethesda Balm

These two pictures illustrate the pain/pleasure principle at work in Manhattan. As contrasted with the blast of winter on the facing page, the scene above captures a more temperate autumn day at Central Park's Bethesda Terrace, as three stressed locals enjoy the therapeutic values of an alfresco neck massage.

4 / The Inhabitants

Remember the line from the old television show, "There are eight million stories in the naked city?" Well, I don't know about the eight million, but what a wonderful cross-section of people we have in this polyglot town. And it's worthwhile attempting to capture a number of them with a camera.

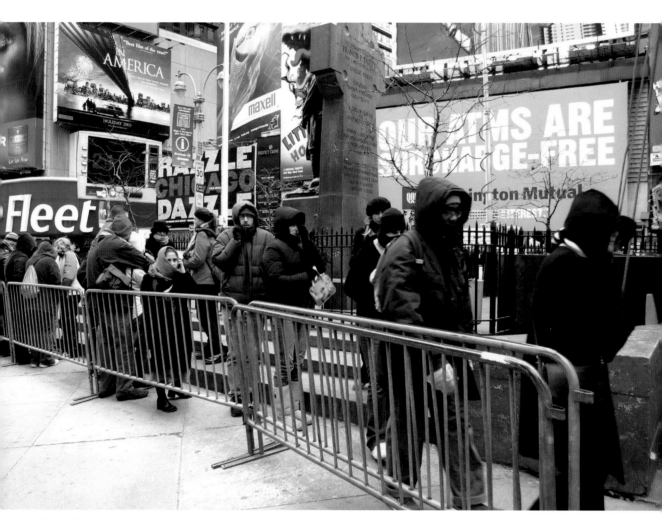

Frigid Queue

On one of the coldest days of the year, New Yorkers and tourists brave the icy elements to stand in a Times Square line for cut-rate theater tickets.

Plaza Sweetie

In Living Memory

(Captions on facing page)

Statuesque Gams

Posteriority

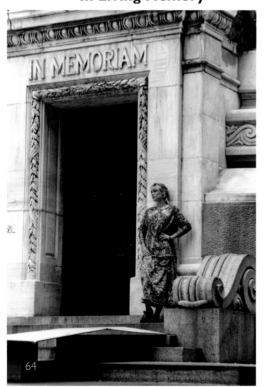

64

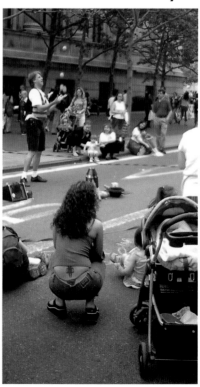

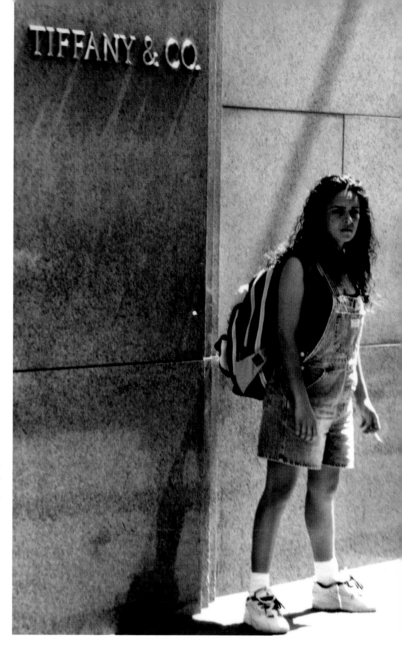

If women tend to show up more in my photographs than men, it's because they usually present more interesting images. Let's face it – the most fascinating women in the world can be found on the streets of this fair city. They deserve someone to happen by toting a camera. . . .

Anomaly

I was struck by the haunting expression on this woman's face (right) and her un-Tiffany outfit and body language – so I cropped everything else out of the picture to heighten the effect.

FACING PAGE

The woman in front of The Plaza (top left) – you can recognize the hotel by the red window boxes – displays a characteristic New York expression and pose. The two ladies in front of the Public Library (top right) constitute a case of life imitating art – their long legs echoing the shapely limbs of the water nymph. An attractive woman and a cold mausoleum come together (bottom left) to form an interesting combo that isn't meant to connote anything in particular. Would you believe me if I told you I was totally focused on the street juggler (bottom right) and didn't even notice the foreground mother's thong and tattoo until I saw the image in the computer?

Self-Promotion

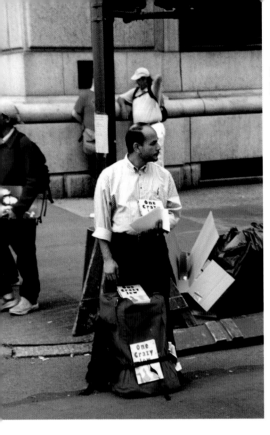

Go-Go Banker

Howdy, Ma'am

BREAKFAST
EGG, CHEESE,
HAM OR
SAUSAGE
ON A ROLL
$1.35
WITH COFFEE
$1.75
6AM-11AM DAILY

Modern Times

In the interesting sights department, here's a book-hawker who is presumably both author and subject of his single tome (top left); a stylish cashier going after new accounts (top right); one of our polite New Yorkers standin'-on-the-corner-watching-all-the-girls-go-by (bottom left); and the owner of an expensive means of seeing up and over the crowd (bottom right).

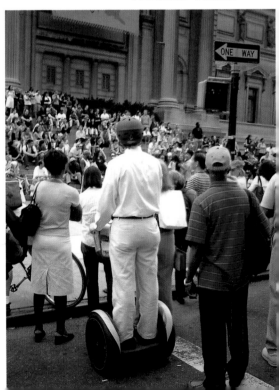

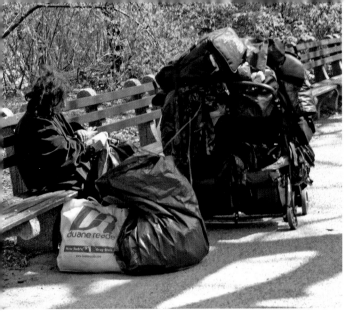
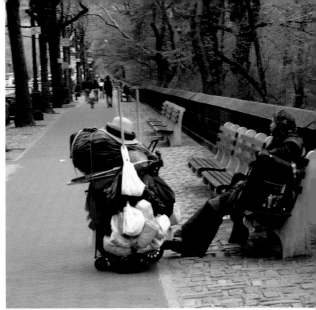

Benchwarmers

The street people of New York are often on the go, but can also be found taking a restful break on one of the many benches located in and around Cental Park.

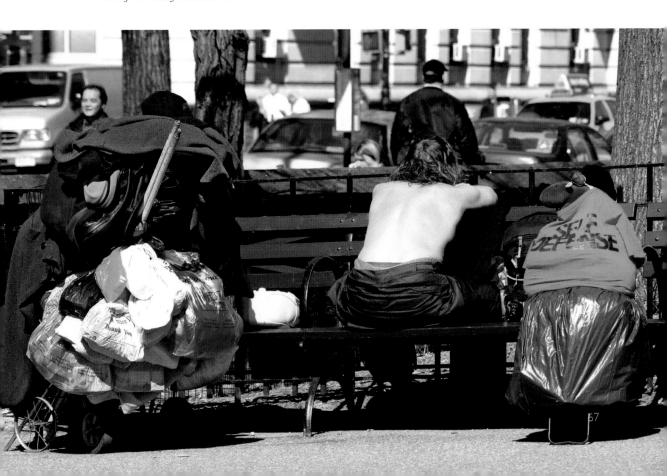

When it snows in New York – which seems to occur a lot less often than when I was growing up here as a kid – I invariably grab my camera and head out to the streets. Even if the precipitation doesn't amount to a picturesque blizzard, the white stuff on the ground changes the way the town normally operates – which can make for some compelling images.

Snow Job

Jammed Pram

Snow removal (above) has progressed from the days of the shovel, although that old-fashioned implement is still very much in evidence after a storm. Maneuvering through the slush on street corners (right) – especially with a baby carriage in tow – can prove to be a tricky proposition.

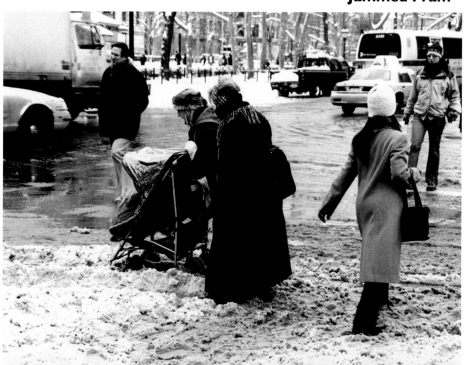

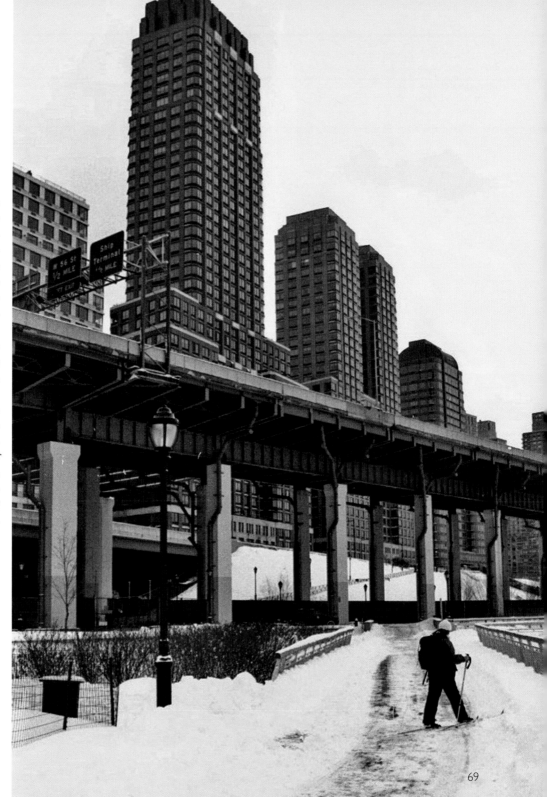

The promenade along the Hudson River – which runs from the Battery all the way up to the George Washington Bridge – is ideal for a cross-country skier. This one, at around 70th street, is doing her thing under the shadow of the West Side Highway and Donald Trump's latest development.

Cross-Country Commute

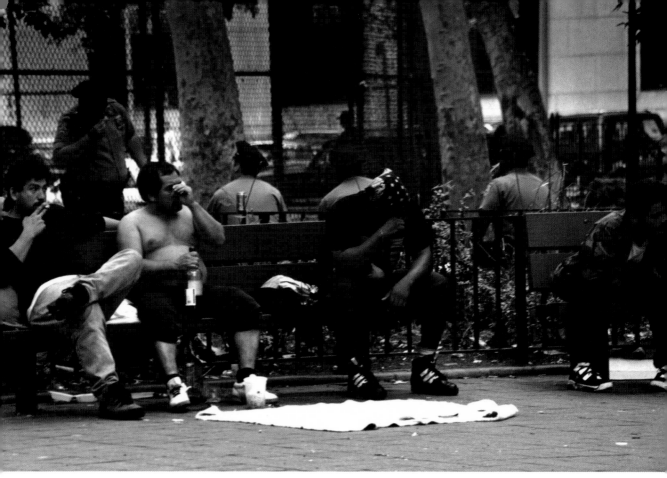

Good Fences Make Good Neighbors

Another theme that's played out on the streets of New York is guys just hanging out. For example, here are some lunchtime denizens on the steps of an august Fifth Avenue church (left), giving the passing girls a glance or two. What caught my eye in the scene above is the juxtaposition between the disreputable-looking group in the foreground (one of whom is wielding a bottle that presumably doesn't contain diet soda), and the local constabulary across the narrow divide. As Cindy Adams would say in her New York Post column: Only in New York, kids, only in New York.

Sittin' on the Corner

What's Up?

Stations of
the Cross

Street processions are very much a part of the life of Manhattan, as witness this Good Friday entourage on the Lower East Side (left). New Yorkers are always gawking at something; these Chinatown onlookers (above) were watching the police make an arrest across the avenue. The artist (right) has planted his easel on the banks of the sailboat basin in Central Park. These gentlemen (below) keep our pavements strollable.

Digital Precursor

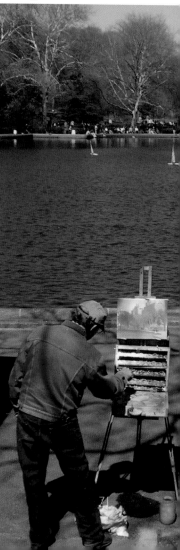

The Sidewalks
of New York

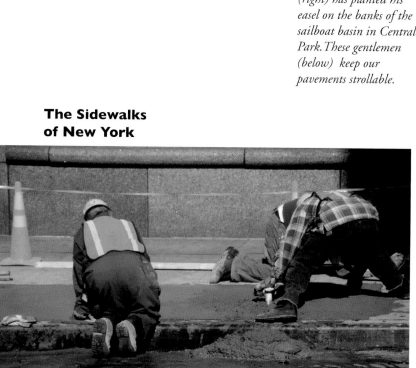

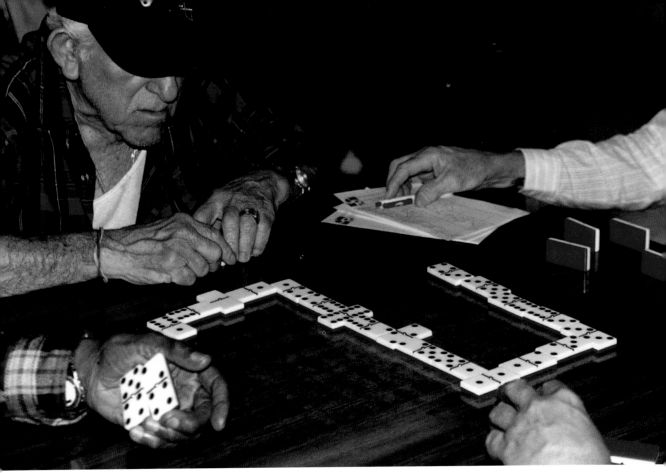

(Caption on facing page)

Domino Theory

New Yorkers love to play games, and they do so with great intensity (as witness "Chess Men" on p. 2).

High Rollers

Open air games are the ones most available to the photographer. What attracted me about this shot (right) was the intensity of the expressions of both players and onlookers in this small Chinatown park.

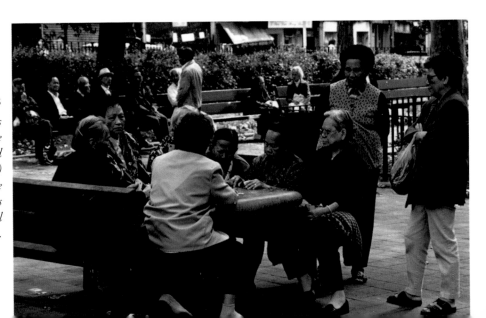

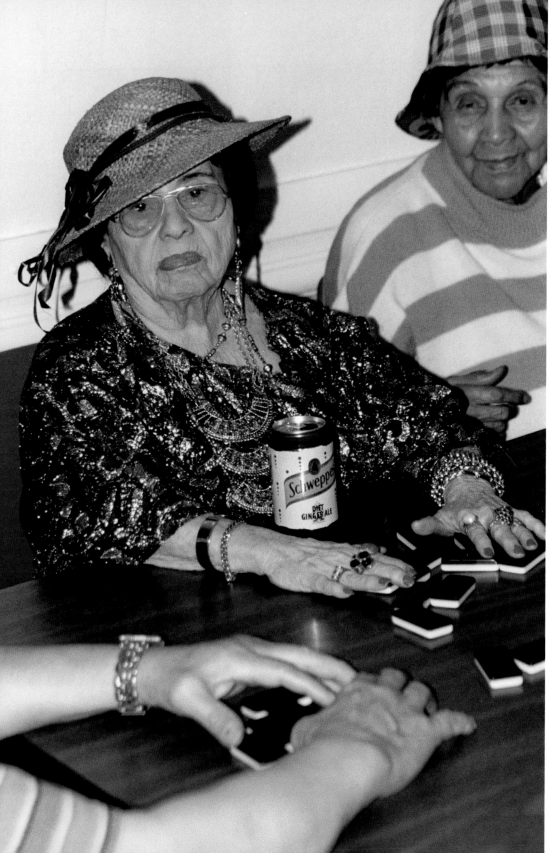

The two domino-related pictures (left and facing page, top) were taken at Goddard-Riverside Senior Community Center, where the players take their game very seriously. (I go there every other week and, in a different room, play the piano for singalongs with the seniors.)

Auntie Up

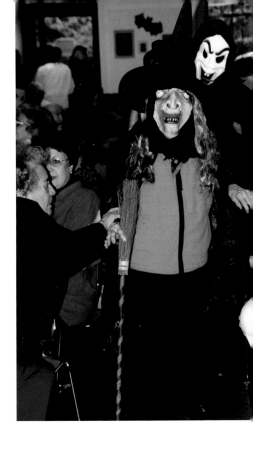

Halloween Hellraisers

The seniors at Goddard-Riverside (where the dominos dominate in the adjoining room) like to slip into costumes for special events like this hotly-contested Halloween fashion show competition.

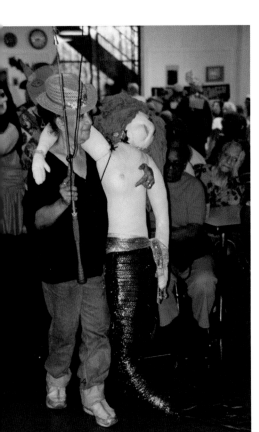

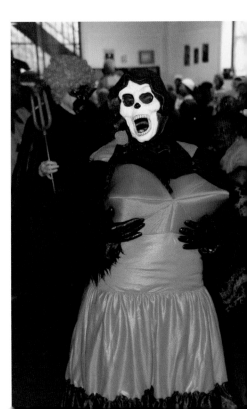

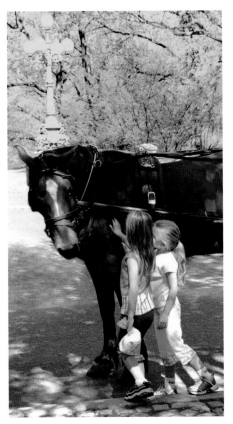

Some of the most heartwarming pictures available in the Big Apple are of children. They tend to be less restrained than adults and often let their emotions show – to the photographer's advantage

These two little girls (left) had just gotten out of a hansom cab after a ride around Central Park, and they wanted to express their gratitude to the horse with a hands-on "thank you." Your mind can supply the dialogue for the imaginary interplay between the Rockefeller Center water sprite and the little boy (below left). I was struck by this young girl's fascination with a rock band in Washington Park (below right).

Fan Club

Come On In

Music Hath Charms

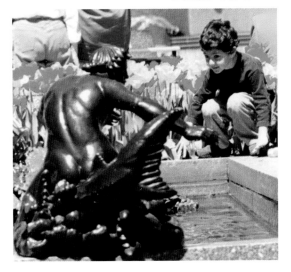

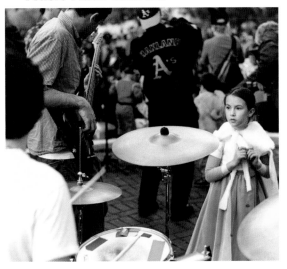

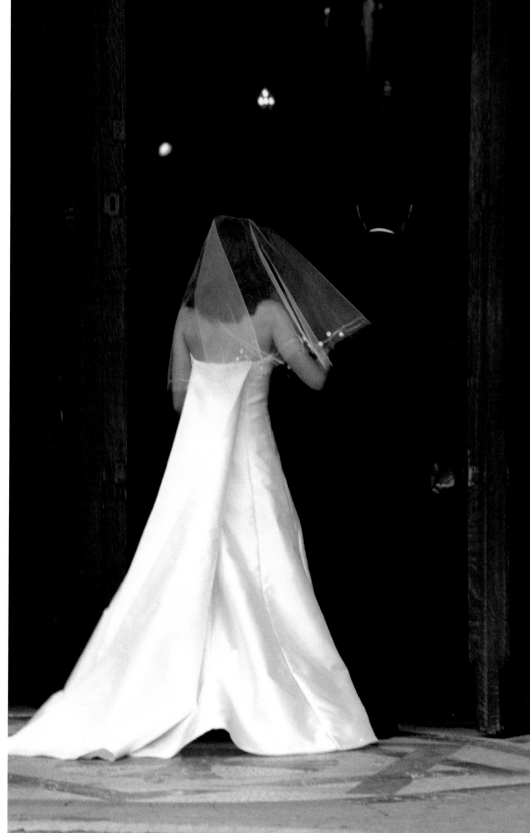

*I was taking
pictures on
the campus of
Columbia
University, which
has some interesting
structures, when
I happened upon
the chapel. A bride
was just outside
the door, about to
enter the church on
her father's arm.
I managed to snap
one shot before they
disappeared inside.
Luckily, you can
glimpse enough of
the chapel interior
to give the picture
both depth and
added significance.*

Daddy's Girl

Columbus Avenue Carnival

*New York street fairs –
many of which are
single day events –
offer manifold
photographic
possibilities. These
shots were taken at
one such event on
Columbus Avenue
in the streets of
the 70's.*

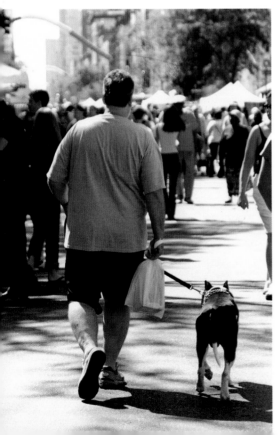

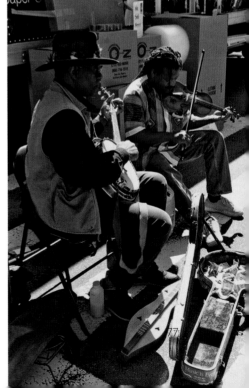

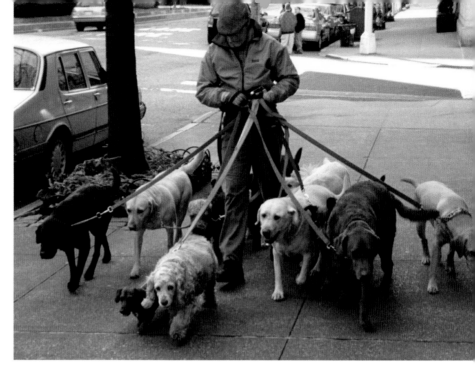

Squirreled Away

Mush!

Animals abound in Manhattan, from the determined-looking canines out for a stroll (above right), to the nut-gathering park inhabitant (above left), to a boy-poodle love fest (below left), to the sheep at the Children's Zoo being fed by my son Tom and his daughter Delilah (below right).

Man's Best Friend

Good Shepherds

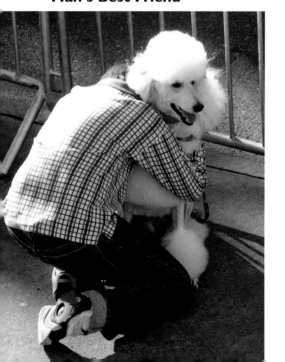

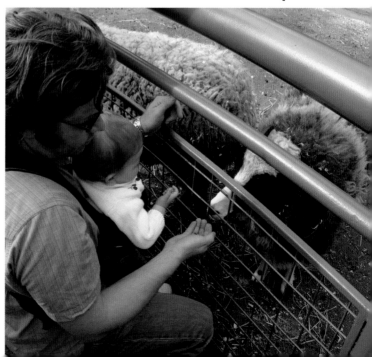

Waiting for Goldilocks

A commonplace scene in one neighborhood takes on added interest when observed by those unfamiliar with it. I don't get down to 23rd Street too often, so these bears outside a flower shop – which I have a feeling are a regular fixture – caught my eye as I happened by one day.

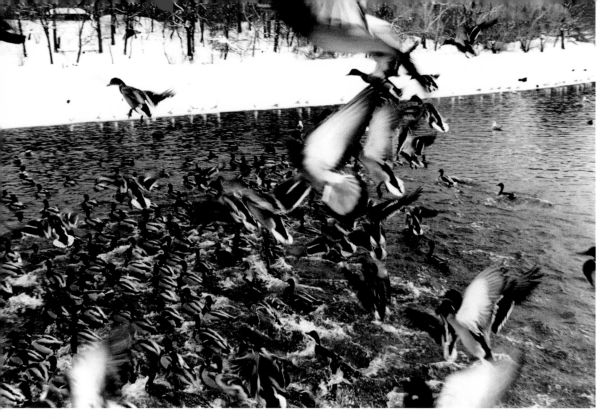

Duck!

There are always ducks in Central Park, but one winter day I came upon a wall-to-wall convention. Every once in a while, something would frighten them, and a number would take to the air. I shot this scene in both color and black & white, but preferred the latter results.

Duck Soup

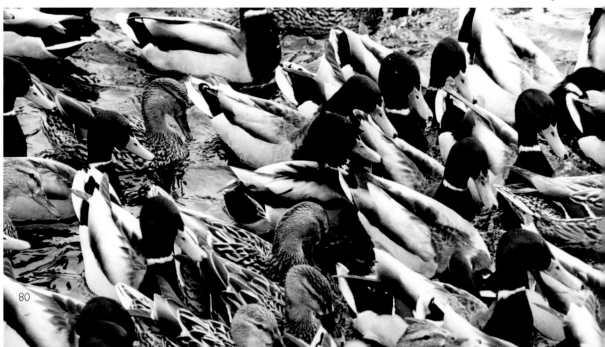

Next door to the ducks, the swans and pigeons (right) each rule their respective roosts, resulting in this Mexican standoff. The scene below, taken on upper Broadway, is the pigeon haven equivalent to the Central Park duck convention. Black & white works well for this kind of shot, but the real key is getting up close with a zoom lens.

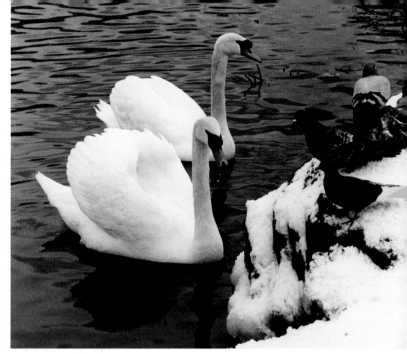

Turf War

Pecking Order

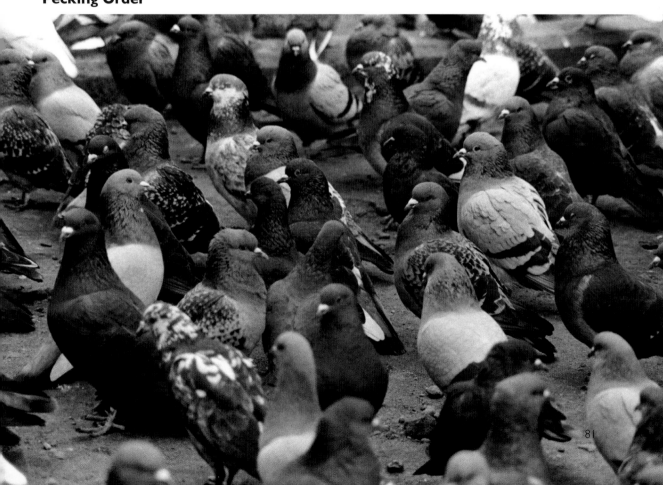

The Macy's pageant on Thanksgiving day may be the splashiest of the year, but New York is home to any number of more modest parades throughout the spring, summer and fall months. The viewing areas are less crowded, so you can usually find a good vantage point to snap some worthwhile pictures.

Horny

(Captions on facing page)

Psychodelic Saxes

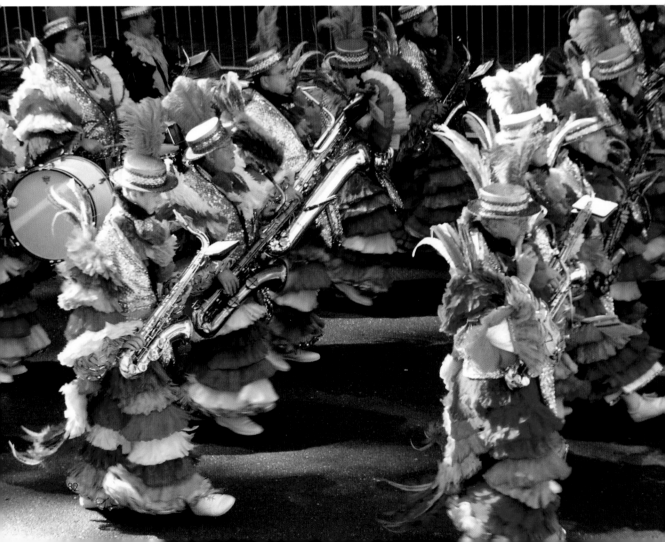

The pictures on these two pages are from the 2003 version of the Columbus Day Parade, which I watched from a second story open window on Fifth Avenue. There were some outstanding brass bands (facing page, top), but the colorful Mummers (facing page, bottom) stole the show. There were also moments of humor – both intentional (right) and strictly in the mind of the beholder, as below where I've juxtaposed the proud steeds and the pedestrian squires who follow in their wake.

**Mobile
Commode**

Being Prepared

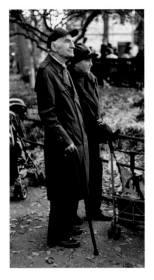
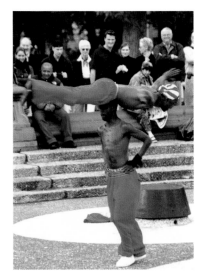
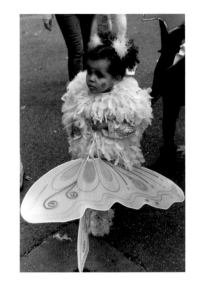
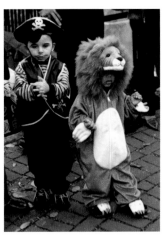
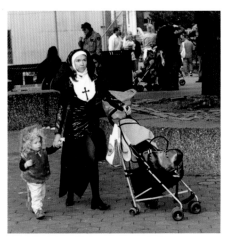
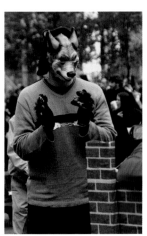

(Captions on facing page)

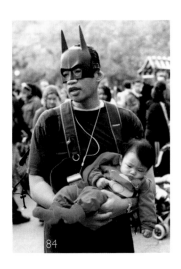
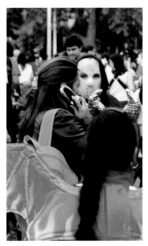
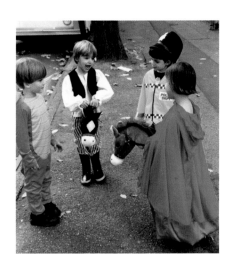

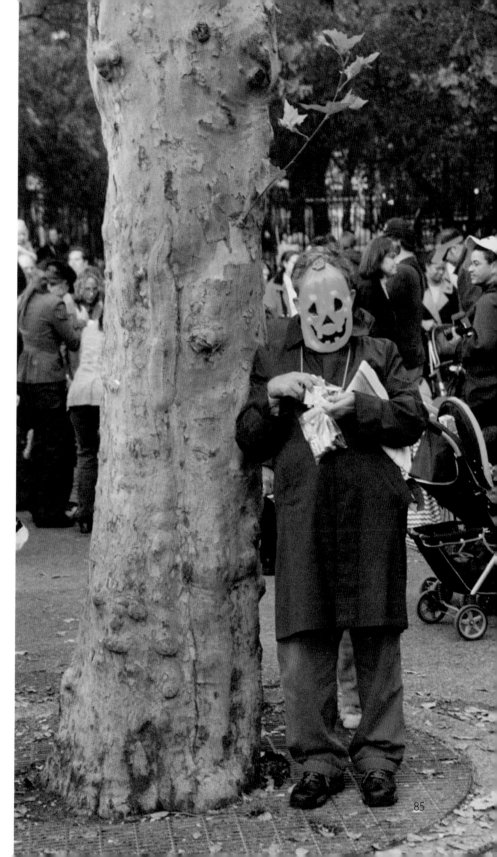

Speaking of parades, on Halloween – in the afternoon before the annual nighttime Greenwich Village extravaganza – there's a children's procession around Washington Park. I recommend it highly for sights such as those in the montage on the facing page – adorable children, fanciful adults, acrobats, the works. But for me, no sight quite compared with the chilling about-to-pounce masked image on this page.

**Have a
Nice Candy,
Dearie**

85

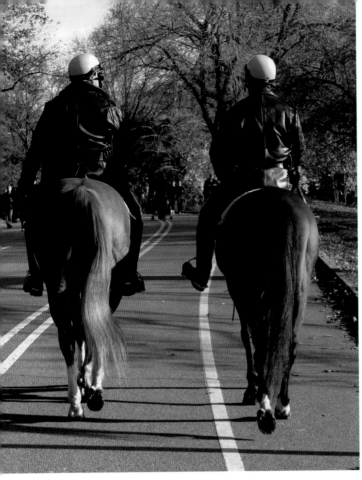

High-Tech Constabulary

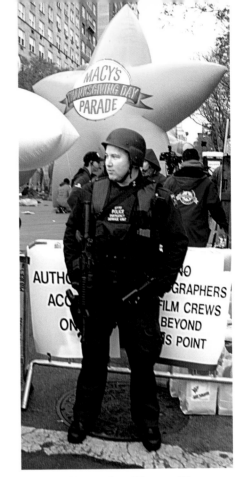

Vigilant for Sharp Pins

No More Fort Apache

Here's a salute to the men in blue. New York's Finest are much appreciated in these troubling post-9/11 days – patrolling Central Park the old-fashioned way (top left), standing sentinel over the Macy's balloons (top right), and [fancifully] waiting their turn to be spoiled in the establishment located behind their vehicles (left).

Something touched me about the nonchalant posture adopted by the man in the foreground, poised as he is before the majesty of the halls of justice. I thought to myself: in a town where many of its denizens are constantly looking over their shoulders, this man is relaxed and unconcerned with it all – he clearly has nothing to be afraid of.

Clear Conscience

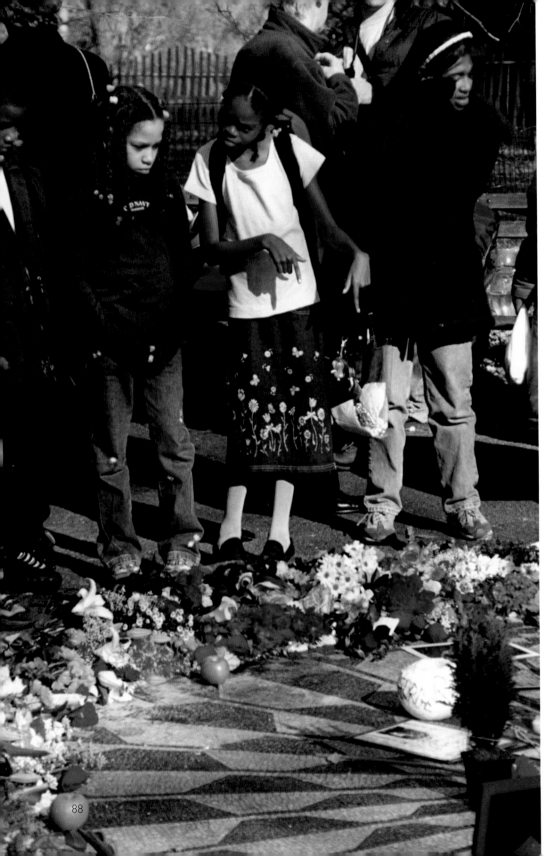

Ex-Beatle Condolence Call

This was taken at the impromptu memorial in Central Park's Strawberry Fields shortly after George Harrison died. The expressions on the faces of the three girls – and the gesture by the one in the middle – really caught my eye. This was the first picture I ever had digitally enlarged, mounted and laminated, which is now my preferred way of handling these kinds of shots – whether or not taken with a digital camera (see the discussion in Chapter 6).

5 / Telling Tales

This chapter is devoted to pictures which tell a story, or can be made to suggest a tale, or that touch some emotion – humor, pathos, good cheer – in the viewer. These scenes are not so easy to find, but when you do, you've got something really worthwhile.

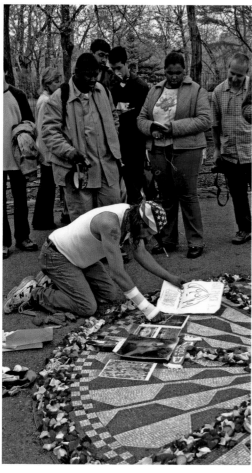

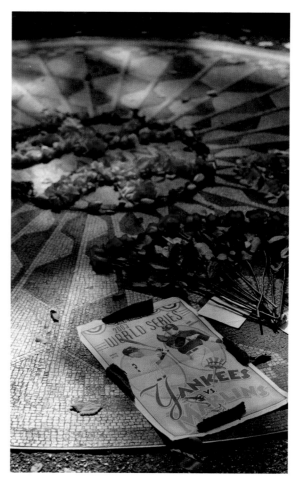

Then and Now **Imagining Victory**

As I took the left-hand picture, I found myself wondering what the onlookers were thinking about the tribute this throwback hippie was paying to John Lennon. I'm not sure the right-hand scene was what Yoko Ono had in mind for the "Imagine" memorial, but New Yorkers have a way of making their shrines do double duty. No amount of wishful thinking was able to help the Yankees in '03, however – somebody up there liked the Marlins.

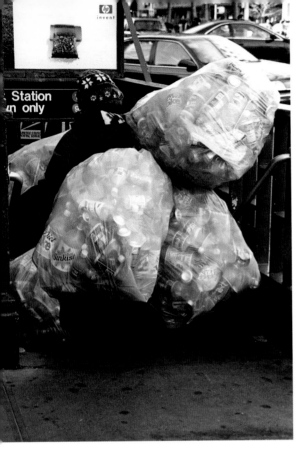

The city is home to a number of less fortunate souls. Some of the pictures I like best show them coping with their situation. There are many different ways to earn a living in New York, and this man (left) has found one of them. You have to respect his determination as he heads into the subway with his heavy load.

I felt a similar admiration for the older man (below), piling his possessions onto a bike (instead of the more common grocery cart). By the way, people have asked me how the wolf-and-glove poster ties into the basic subject matter. I'm not sure, but I like the effect. Usually I want my intent to be clear, but a little mystery isn't bad on occasion.

A Good Day's Haul

U-Haul

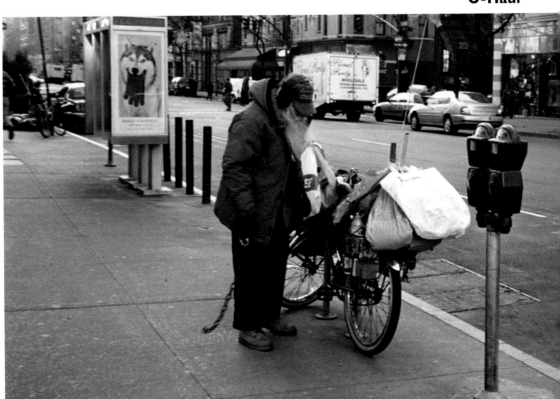

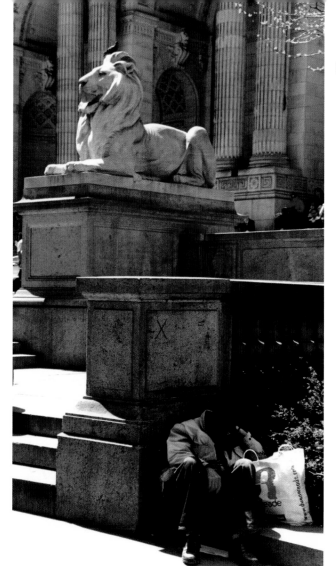

Low and Mighty

The man in front of the Public Library (left) might just be a guy on his lunch break who shopped for necessaries at Duane Reade and is now taking a nap – but I think not. There's some despair in his posture, which is exacerbated by the contrast between his shadowed face and the boldness of the lion's erect carriage.

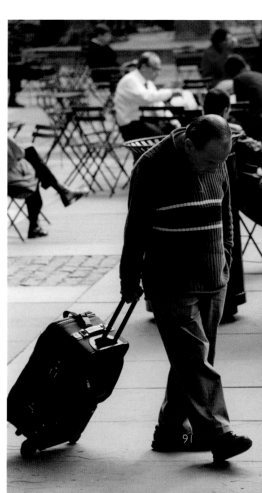

Similarly, for all I know the man walking through Bryant Park (behind the Library) is perfectly happy and well-adjusted, leaving his hotel after a successful business trip, heading for a plane back to Cleveland. Still, something in the tilt of the man's head suggests that things aren't quite so rosy.

With Baggage

91

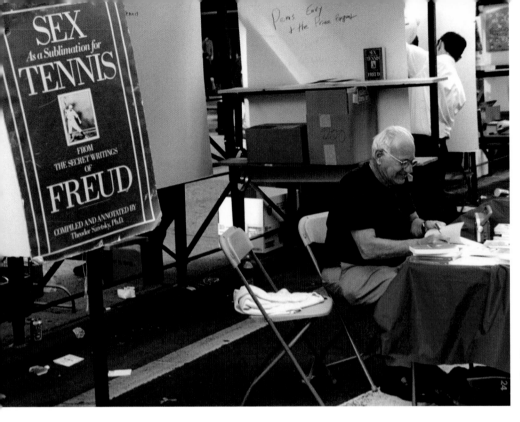

**Coitus,
Anyone?**

(Captions on facing page)

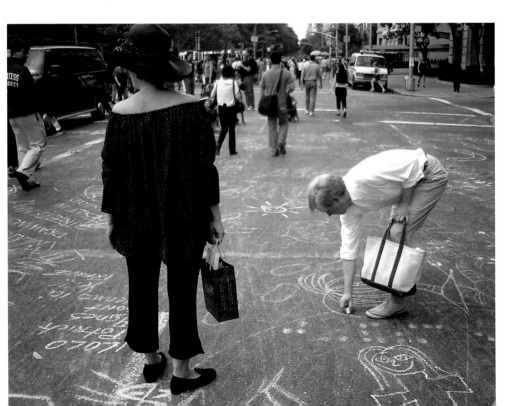

**Dear,
Must
You?**

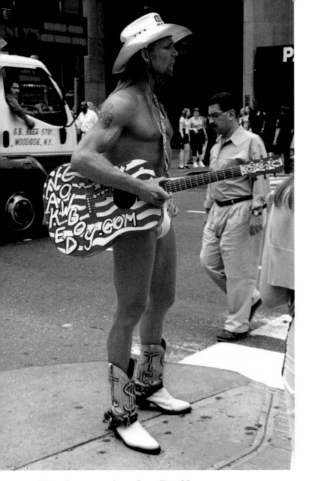

Buckaroo in the Buff

Although this urban cowboy (left) is now a familiar sight in the Times Square area, I had never seen or heard of him until one day when I was riding by in a taxi. I yelled at the cabbie to stop, jumped out, and took the picture. What I didn't spot then (but appreciate now) is the indifference of the guy walking by him – in contrast to the truck passenger, who is presumably banging on the door and uttering some foul jibes. As for the frightening gentleman on the rock (below), I believe his bark may be worse than his bite.

Boo!

FACING PAGE

Some of my favorite photos contain a humorous touch. For me, the humor in the top picture lies in the man's gleaming expression as he autographs copies of his unusually titled book at the Fifth Avenue Book Fair. In the bottom picture, what we have is an impatient woman – seemingly not at all happy that her man is indulging his artistic instincts on the sidewalks of New York.

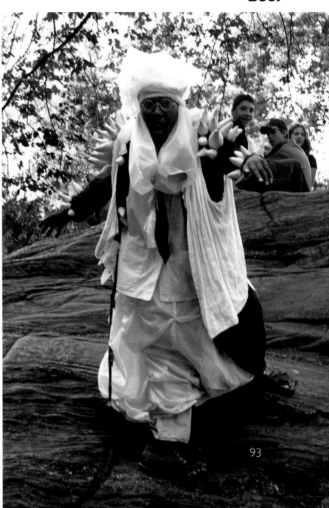

93

Kindred 'Do's

This scene (left) caught my eye one day near Bethesda Fountain. I have a feeling that both owner and canine patronize the same hair salon. To emphasize the point, I cropped almost everything else out of the picture.

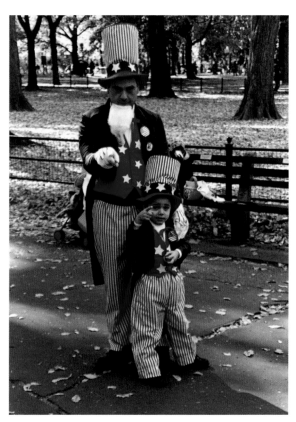

310 in the Shade

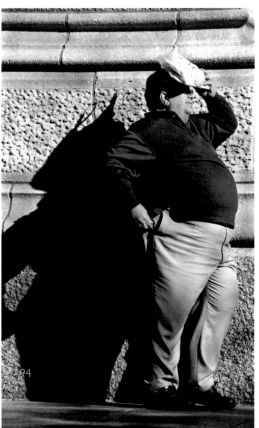

Uncle Sammy Wants You!

Unlike most of my photos, this father and son duo (above) were posing for the camera – but the scene is sufficiently bizarre that it really doesn't matter. The corpulent gentleman (left) caught my eye – most notably for the sizeable shadow he cast on the facade of St. Peter's Cathedral.

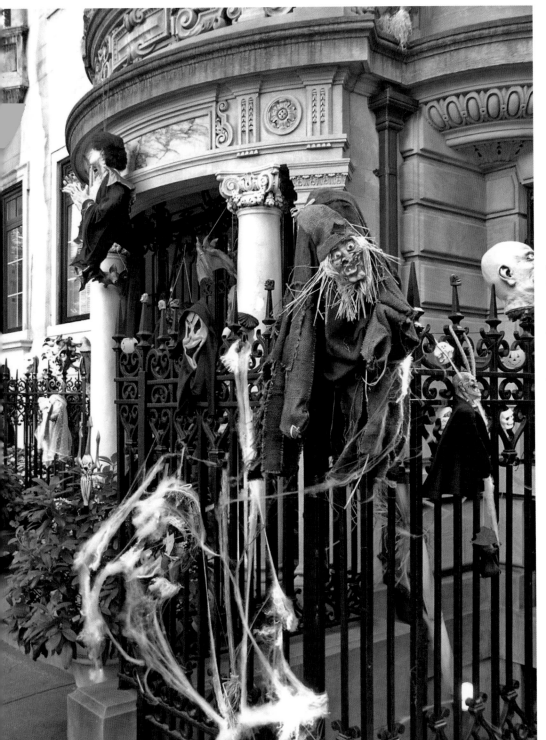

These Halloween ghouls and goblins transmitted a special piquancy, inhabiting as they did some fancy digs on the Upper East Side.

Haunted Town-House

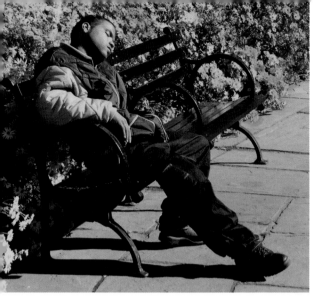

Central Park is apparently a mecca for those desiring a short nap. These gentlemen grabbed 40 winks in the Conservancy Garden (left), near the Bethesda Fountain (right), and on the Mall (below), respectively.

Technicolor Daydream

Spring Snooze

Making Himself Right at Home

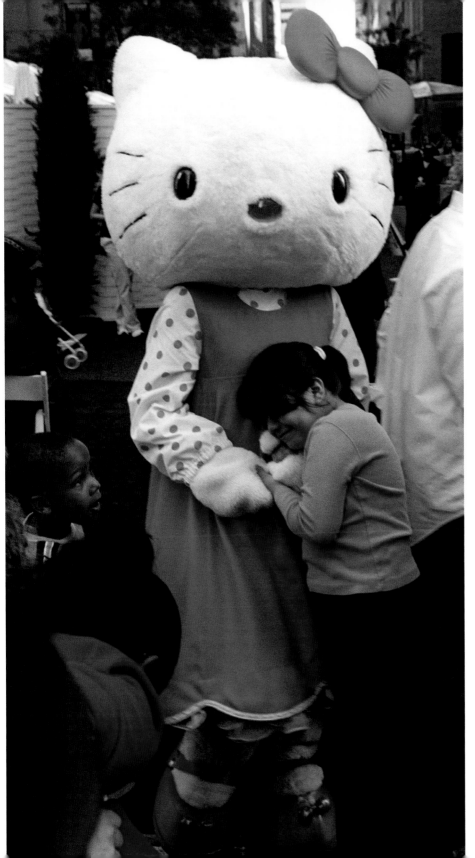

With this photo, my first thought was to capture the kitty at the Book Fair. Then I was touched by the warm expression on the girl's face. Only later was I taken with the boy's impatient desire to get some of the same TLC – which provided my title.

Me Next

Some of the most evocative photos in recent years have come out of the 9/11 disaster. I stayed away from Ground Zero at the time – on the one hand, I was reluctant to photograph it, and on the other, I didn't want to go down there and not photograph it. But there were other images of note all around town.

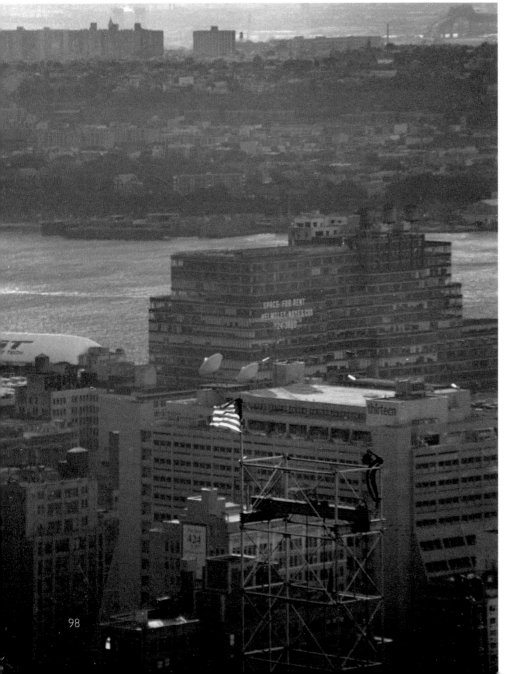

Old Glory

This picture was taken through a window, in the tense days following 9/11. The illuminated flag against the drab back drop of commercial buildings reminds me of the line from the National Anthem, "…that our flag was still there…."

FACING PAGE

At a street fair soon after 9/11 (top), patriotic emblems were much in evidence. The vigil at Union Square produced many images, but this one (bottom) – with the guitar and Jerry Garcia's lyric – stayed with me.

98

My Country 'Tis of Thee

(Captions on facing page)

Goin' Home

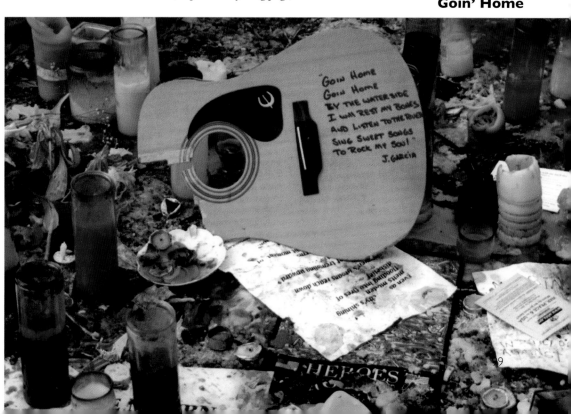

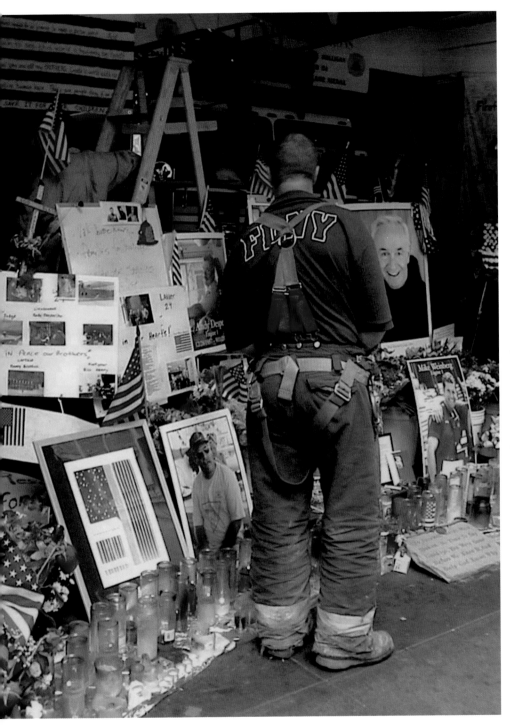

In the wake of 9/11, New York's Bravest had to confront the loss of so many of their number. This evocative scene was taken at the firehouse on West 32nd Street, just across from the church where Father Judd (whose picture is displayed on the right) presided. As the firemen's chaplain, he became one of the first casualties among the rescuers who ran bravely into the Towers.

Lest We Forget

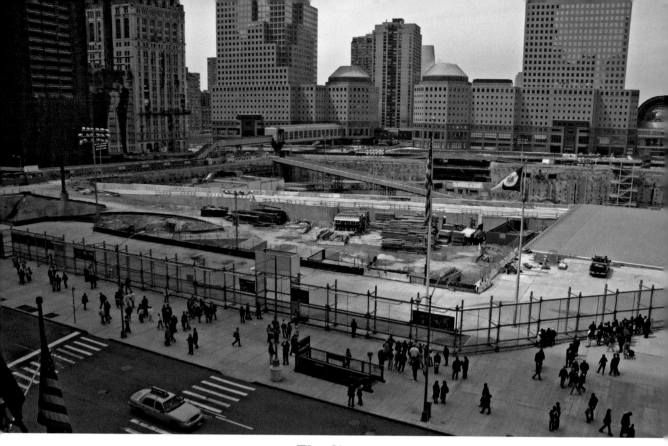

The Site

The Cross We Bear

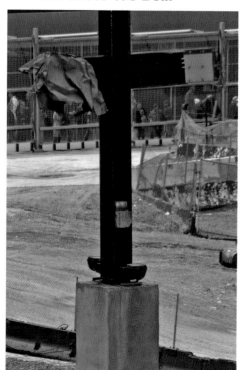

Thirty-plus months after 9/11, the World Trade Center site (above) is a bustle of activity, with one charred girder in the shape of a cross (left) remaining (it's at the very left of the above overview), and a matchbook commemoration dangling on the perimeter fence (right).

Matchless

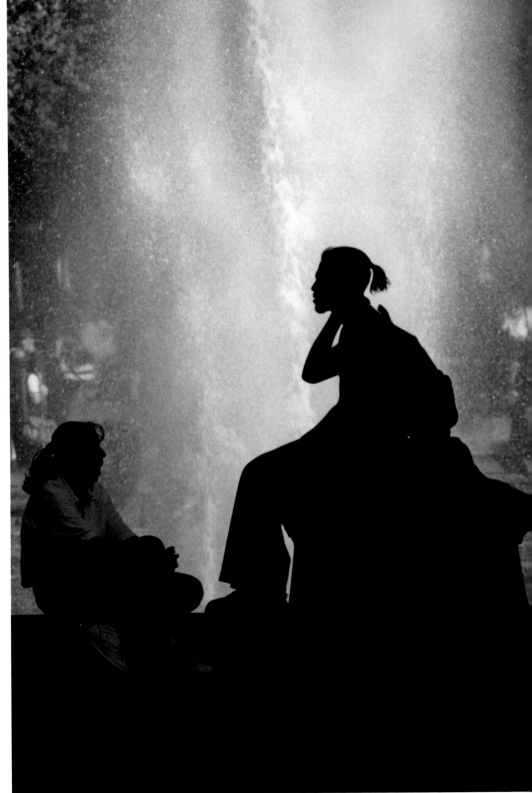

Fountains are spouting all around Manhattan, and they can provide an ideal backdrop for photos — especially those in black & white. When the camera's exposure is based on sunlight emanating from the far side of the fountain, figures in the foreground — like this youthful twosome in Washington Square Park — are captured in dramatic silhouette effect.

Fountain of Youth

6 / Tips on Photographing the Big Apple

Roaming around Manhattan with my camera in recent years, I've picked up a few practical pointers on how to go about photographing the Big Apple – tips I want to pass along in the chapter. What I have in mind isn't anything fancy, and I'll try to stay away from technical stuff and photographic jargon. This is mostly common sense advice, with the pointers illustrated by specific photos.

The first question people often ask me is, what equipment do you use? The implication of the question is that the answer makes all the difference. I'm convinced that's not so. The pictures in this book were taken with a variety of cameras, and though I have my favorites, I don't own anything fancy or prohibitively expensive. I'm convinced that other models are equally good. The technology is so superb today that you can shoot excellent pictures with moderately-priced cameras which do the bulk of the work for you.

In case you're not convinced, check out the picture below, which was taken with a $9 disposable camera!

This view of Bow Bridge in Central Park looking west, shot with a disposable camera, shows that you don't have to own high-priced equipment in order to enjoy photography in New York City.

Here's the number one tip I can offer an aspiring New York photographer: when you hit the sidewalk, have a camera with you, loaded and ready to shoot! In this town, the passing scene can morph into a nifty picture right before your eyes – but if you're not ready to snap, the picture will just as quickly dissolve. This is especially true in the case of shots that feature people or animals.

Busmen's Holiday

Call it racial profiling, but I see this scene as a group of Japanese visitors checking out their homegrown Nikon, Minolta, Sony and Canon cameras in a Times Square shop window – probably comparing the prices to what's available on Tokyo's Ginza. For shots like this, you've got to be in the right place at the right time and be quick on the shutter.

As you can probably guess by now, I try to go for pictures that tell a little story. And even when the pictures aren't that explicit, you can use a little imagination to devise a satisfying tale – whether accurate or not, you'll never know. But don't hold the shutter until you've worked out the full story in your mind – shoot first, and ask yourself questions later. If there's something appealing about the scene – even if you're not sure just what it is – let the camera do its thing right there and then. This is especially true when the subject matter is people on the move.

West Side Story

Just look at this couple – mismatched in size but apparently quite cozy – heading in the direction of some unlikely-to-be-attainable future condominium residences near Lincoln Center. You can cook up your own story here – perhaps a variant on the Jets and the Sharks from the Broadway show to which the title alludes.

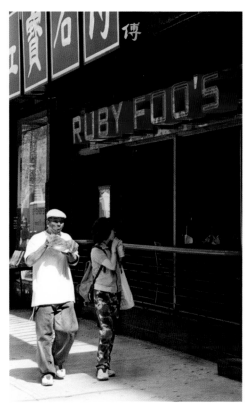

Two from Column C

Here's my take on this one. The man and woman, eating and drinking some fast food fare on the run, pass by one of New York's fine eating establishments, Ruby Foo's on the Upper West Side. He's oblivious, but she's casting a wistful look at the premises – knowing that (at least with this guy) she's unlikely to ever make it inside.

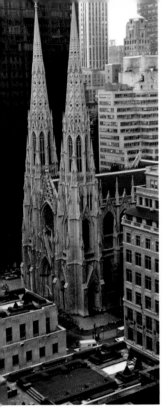

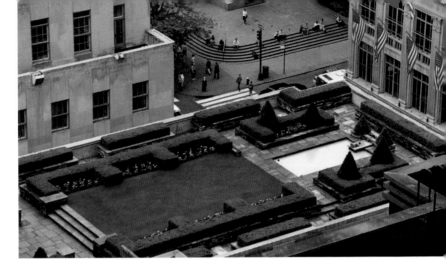

Roof Garden

The View From My Dentist's Office

The shot of St. Patrick's Cathedral (left) from my dentist's office illustrates an important photographic proposition in Manhattan: don't limit yourself to the views obtainable from the street. This is too vertical a city, and you can't pass up opportunities to get way up there and shoot downward. But, you need to have a camera with you, and then remember to look out the window. You never know what you might see while waiting for the Novocaine to kick in This particular dental visit went on interminably, so at one point I leaned further out the window and zoomed in on the garden (above) atop one of the smaller Rockefeller Center buildings. (It's also visible at the bottom of the St. Patrick's shot.) In a similar vein, to get a good shot of this Central Park ballfield framed by the East Side skyline (below), you need to mount the high battlements of Belvedere Castle.

**Play
Ball**

When I come upon an interesting scene, I often shoot it two ways – first, as a wide angle image, taking in the whole panorama, and then as a close-up of the most interesting segment. A zoom lens is a great help in doing this. If you don't have one (and also don't have two fixed lenses with different focal lengths), then the only way to accomplish that kind of duality is to stand back for the first shot and then move in a lot closer for the second, so that the segment of interest fills the viewfinder.

If you've taken just the wide angle shot at the time and only spot the choice segment later when viewing the developed print, you can achieve a similar effect by cropping out everything but the segment and having that portion blown up. But the blow-up will not be as sharp as if you'd taken the segment separately at the outset.

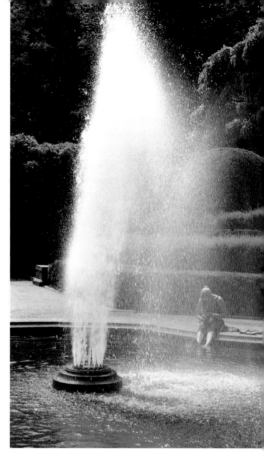

Summer Shower

These photos represent an instance where I took only the wide angle vertical picture (above) at the time. Later, I realized that a close-up of the woman sitting at the base of the Central Park fountain was actually a more interesting shot. So I cropped that horizontal part out of the vertical picture and blew it up. Here, it didn't matter much that it became grainier, since the spray of the fountain works against clarity in any event.

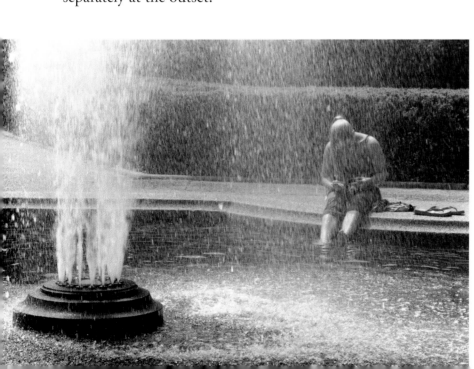

When you look at a scene before you, your eyes take in even more than a wide angle lens. And with your eyes, everything is in focus. This is good for purposes of vision but may or may not be for photography, since it doesn't differentiate between what's important to the scene and what's not.

To me, the key to shooting pictures – in Manhattan and elsewhere too – is finding what's significant in that total picture your eye sees, and then homing in on that. If it's only a small part of the entire scene, then you have two choices. One is to move in very close to what you want to emphasize – which can prove to be awkward, especially if the subjects are people or animals who are disturbed by your presence, and who in any event won't act or look the same as they would if they weren't aware you were photographing them. The other way is to use a telephoto or zoom lens, which is usually my preference. If the smaller scene itself contains elements of unequal importance, you can highlight the significant part by having it in sharp focus while making the rest of the scene a little fuzzier.

Triumphal Perch

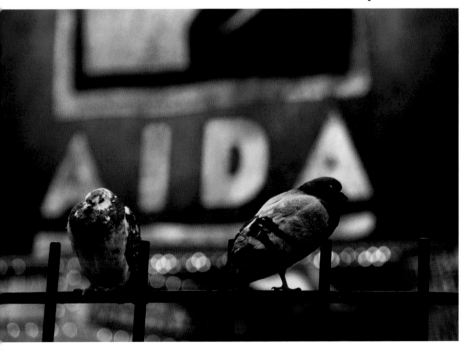

There's no logical relation between the pigeons and Aida, other than the pun in the title (pardon me, Bizet). It's the colorful elements of the sign contrasting with the black, white, and gray of the birds that attracted me to this telescopic shot. So I put the pigeons in sharp focus and let the sign slip out of focus, although still legible.

There are so many interesting objects around Manhattan to photograph. But I find that most pictures can be improved if they contain one or more persons. I'm not talking about snapshots of family and friends, smiling into the camera, posed in front of some point of interest. I'm talking about people who are sitting or standing where they are for their own purposes, and who don't even know that you – the photographer – exist. It adds a human dimension, as well as providing a helpful yardstick as to size.

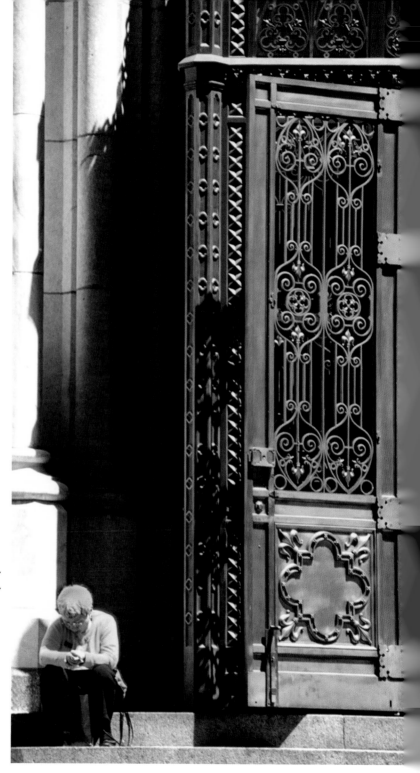

Alfresco Prayer

Here, my eye was drawn to one of the large and ornate side doors of St. Patrick's Cathedral. Then I noticed the woman seated next to the door, presumably deep in prayer. Her inclusion in the picture serves to humanize it, informs the viewer that the door is part of a church, and gives a visual clue regarding the height of the door.

When shooting an object – a building or a statue, for instance – the tendency of most amateur photographers is to include the entire object. That's probably a good idea for at least one of the shots you take. But you also ought to experiment with whether the picture can be improved by including only a portion of the object in the frame – especially when it's still identifiable from that part. This often requires a fresh way of viewing a scene that may not be obvious when you first come upon it. A little imagination is required, as well as the flexibility to move around and shoot from a different angle or elevation.

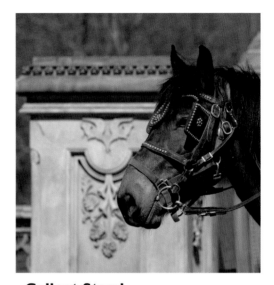

Gallant Steed

(Captions on facing page)

Rinkmaster

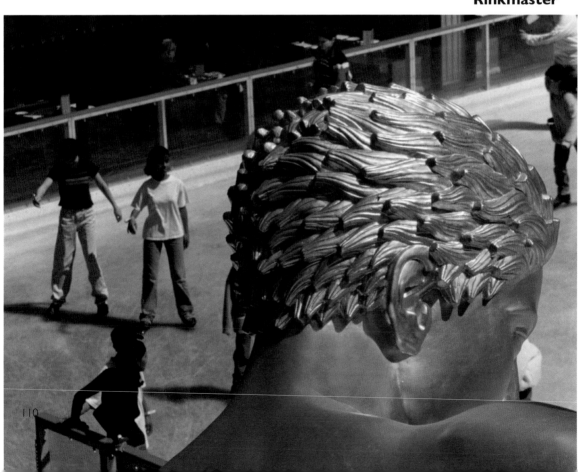

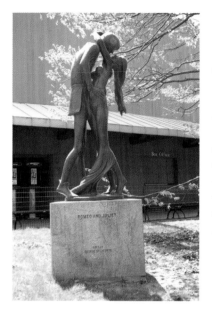

Anyone who has visited Delacorte Theatre in Central Park has passed by the statue of Romeo and Juliet (left). But a zoom lens, plus some helpful spring foliage, highlights the sensuousness of the young lovers (right).

Star-crosssed Lovers

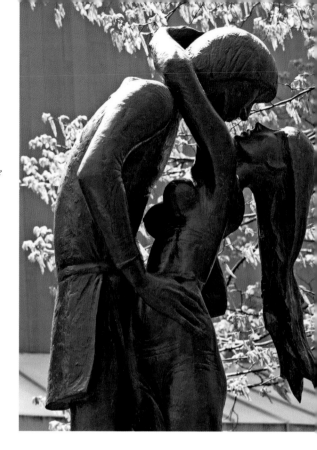

FACING PAGE

Everyone is familiar with the golden statue of Poseidon overlooking the skating rink at Rockefeller (bottom). So I tried to make the picture more dramatic by just including a little of each. In the process, I was able to call attention to how massive the statue is by the great disparity in size between its head and the skaters below. Likewise, you don't need to see the rest of Old Dobbin (top) to know that this is a horse, framed by a handsome Bethesda frieze.

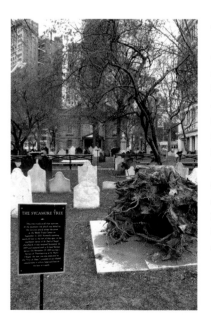
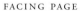

Tree of Hope

St. Paul's Chapel was a sanctuary for the workers at Ground Zero after 9/11. In its churchyard (left) there remains today a segment of a tree felled during the attack — a symbol of hope and love. But the image is a lot more effective when it concentrates on the severed roots.

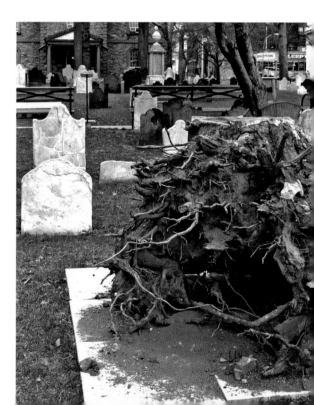

It's not so easy to spot and be able to capture a humorous scene, but when the occasion presents itself, you have to be ready and go for it.

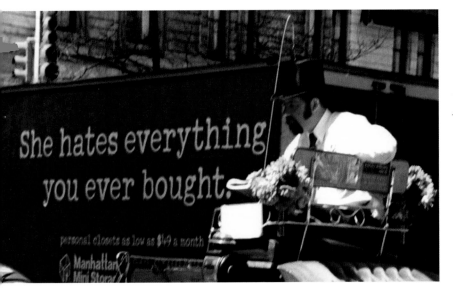

...And Especially That Hat!

I saw this truck with the punchy logo coming through the space where the hansom drivers wait their turn just north of the Plaza Hotel. I snapped the truck several times, hoping the logo would match up with something interesting or humorous. The cab driver's high hat did the trick.

Pictures that create a sense of mystery are especially desirable. I don't know any tricks on how to obtain such shots, other than being alert to the opportunity.

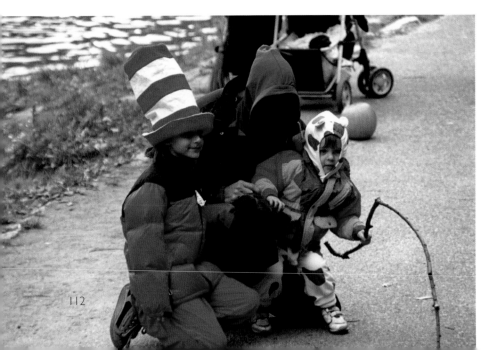

Film Noir

The stark blackness in the face area of the purple-hooded figure gives this otherwise Norman Rockwell-esque Halloween picture an eeriness that I fancy.

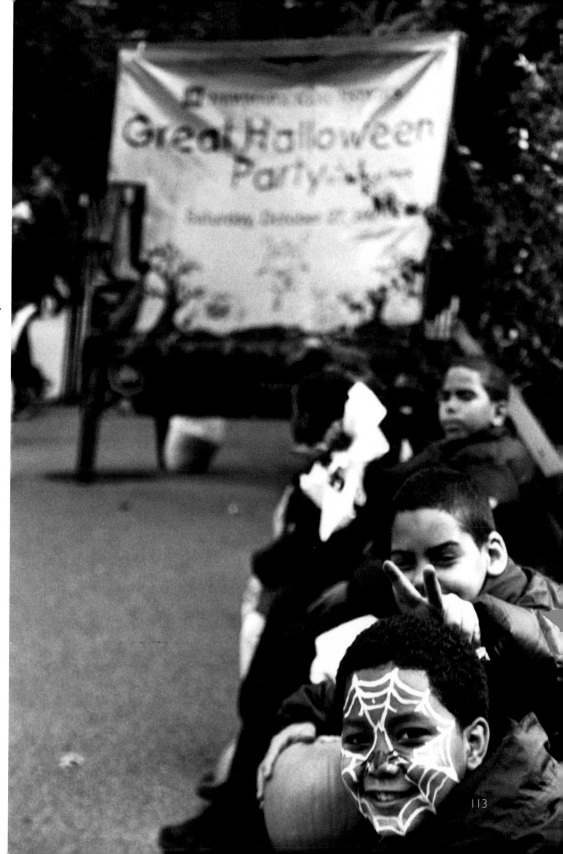

Devil May Care

This Halloween shot is a good example of a picture that works well in black & white. Notice that the two kids in the foreground are in focus, while the out-of-focus (but still legible) sign in the background tells the viewer what the occasion is.

113

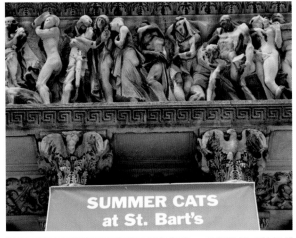

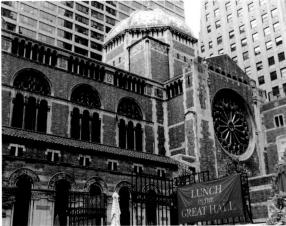

Manhattan is full of iconic structures and scenes, which can be useful when you desire your picture to make some pointed commentary on the current state of affairs.

Walking by St. Bart's Cathedral on Fifth Avenue one afternoon, I was struck by what this great institution has to do nowadays to attract parishioners and stay solvent. This led to these three shots, which can be viewed as a commentary on religion in the Big Apple today. I particularly relish the juxtaposition of the "summer cats" banner and the ancient figures in bas relief just above it. By the way, you should know that every Friday there's a vibrant "Jazz at Noon" concert and a decent meal in the Great Hall that I heartily recommend. . . .

...To Say Nothing of Bingo

Stepsister

Han[d]som[e]

I talked about juxtapositions and contrasts in Chapter 2. This page contains some further illustrations of how this device makes for worthwhile pictures.

The juxtaposition of a real life worldly New Yorker with the Madonna-like figure on the door of St. Patrick's Cathedral (above left) makes this picture work. I like the contrasts (above right) between the chic woman in black, the mundane white horse and the plush red carriage. While photographing horse-drawn carriages one day, this truck happened by (below), and I suddenly realized that the truck and the hansom were in the same basic business – transportation.

Long Haul, Short Haul

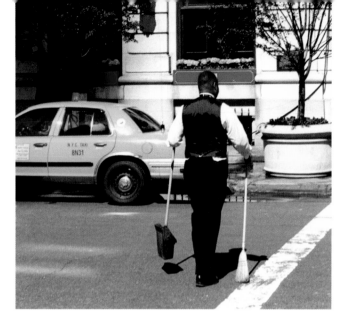
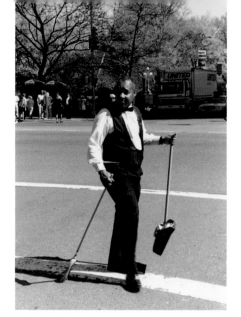

Plaza Manicure

When an interesting shot presents itself, try to shoot it from different angles. Here (above), I was struck by this Bobby Short look-alike maintenance man tidying up outside the hotel. I wanted to capture his face, but I also wanted to show it was The Plaza (note the red window box). So I snapped it both ways and then framed the two pictures together when they were exhibited.

You can have fun with lifelike statues that deceive the viewer. That isn't really Whoopi (bottom left), but one of Madame Tussaud's waxworks. And (bottom right) that's not a flesh-and-blood dog standing tall – the one that the dog on the right is encouraging to come out and play.

Whoops!

Don't Be Such a Stiff

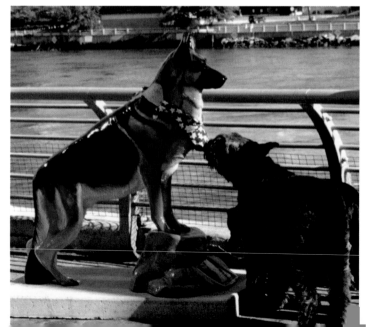

Finally, I want to say a few words – and I promise not to get too technical – about the digital revolution that has taken place in photography during the past several years. When I exhibited my Central Park photographs in April 2000, not a single one of the 225 photos had been taken with a digital camera nor printed digitally; and the same was true in the book incorporating those pictures.

By contrast, in the exhibit of my *Slices of the Big Apple* photos that led to this book – an exhibit held in June 2003, just three years after the Central Park showing – every one of the 150-plus pictures had been printed digitally! In that short period of time, yours truly – along with millions of other photographers – had become a convert.

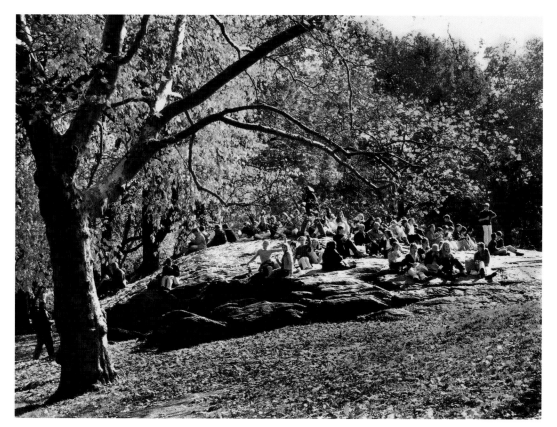

Fall Outing

This picture illustrates what the digital process can do to bring out the visual splendor of a glorious fall day. I never did find out, though, what all these people were doing sitting on a big rock in Central Park.

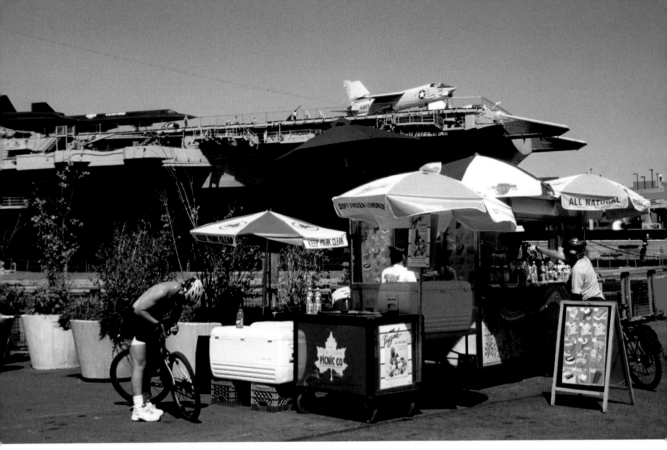

Intrepid Vendors

This picture, taken with 35mm print film, was then printed digitally. I think it perked up the picture – heightening the contrast between the colorful food stand and the grey ship and planes – plus which, I ended up with a fine blue sky.

Not a total convert, though, because the great majority of pictures in the *Slices* show were originally taken with a film camera. But that's one of the beauties of the digital phenomenon. If you're a devotee of 35mm photography, and own a good camera and lenses you'd like to continue using, you can do so – while still achieving many of the advantages of digital.

The key, of course, is transferring your photos into the computer – the heart and soul of digital photography. You can achieve the best resolution with a special scanner that scans negatives and transparencies. If you have a flatbed scanner, you can scan from a print. Perhaps the easiest method (which only costs a few extra dollars) is to ask the camera store developing your film to make you a disc, the contents of which can readily be transferred to the computer.

Recently, I find myself shooting more and more of my pictures with a digital camera. (Roughly forty percent of the pictures in this book were taken digitally, while all of them were digitally printed.) It adds a real dimension to the enjoyment of photography – which accounts for why so many digital cameras are being sold today. First and foremost is the ability to immediately view the picture you just took. What a kick! – and if the subject's eyes happen to be closed, you can retake it on the spot.

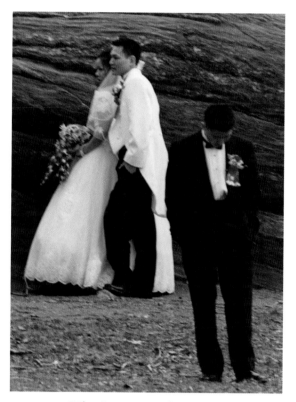 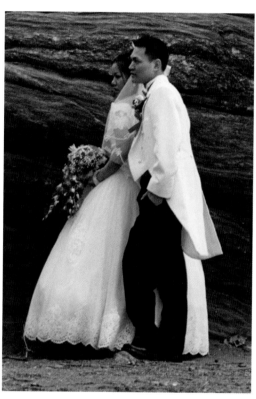

When I came upon this scene in Central Park and snapped my first digital photo (left), I could see from the viewfinder image that the bride and groom were out of focus and the best man in the way. So I eliminated him and adjusted the focus, which resulted in a better shot (right).

Although digital cameras are more expensive than comparable film cameras, the ability to use and reuse those tiny digital cards that serve the function of film results in considerable cost savings – you don't have to purchase film or pay for its development and printing.

There are many other advantages that I won't get into, but – at the risk of getting just a wee bit technical – let me mention just one that really appeals to me. In a film camera, each roll of film you use has a speed (known as the ASA). The faster the film speed (say 800), the easier it is to shoot in low light conditions without a flash. But the slower the film speed (say, 100), the finer the resulting picture (with less grain). Until you finish the roll that's in the camera (24 or 36 pictures), however, you're stuck with whatever speed you loaded in. But with a good digital camera, you can set a different speed for each picture you take. So, if you're shooting in a well-lit indoor setting and don't want to use a flash (which can give off harsh lighting), you set the speed at 800 and take your shot with no problem. A minute later, you find yourself outdoors where it's sunny – so you switch speeds to 100, and end up with a fine-textured picture. It's magic!

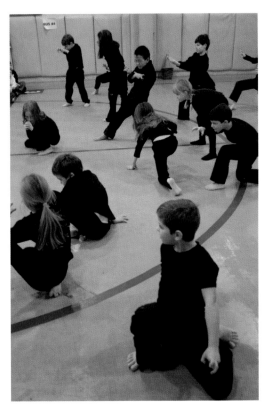

Shooting pictures of an indoor performance by second graders at Dalton School (left), I didn't want to distract them by using a flash. So I set my digital camera to its fastest speed of 1600, and there was just enough light to make it work. Later on that morning, I slowed the speed down to 200 for this sharper outdoor picture of the building's façade (right).

If you entertain the idea of buying a digital camera, you'll hear a lot of talk about megapixels. The more megapixels, the better the picture quality, but the more expensive the camera. What to do? Part of the answer lies in how you intend to use your pictures. One megapixel is okay for e-mailing a snapshot, but not great for printing. Two megapixels will produce a decent 4x6 print; but if you want a good-looking 8x10 enlargement, three megapixels is better. For larger blow-ups, five or six megapixels fill the bill – and even for smaller photos, this gives you a sharper picture, although it does create the need for more storage space on the computer and takes longer to transfer.

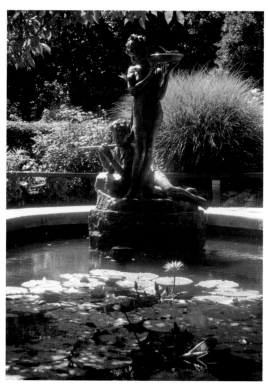 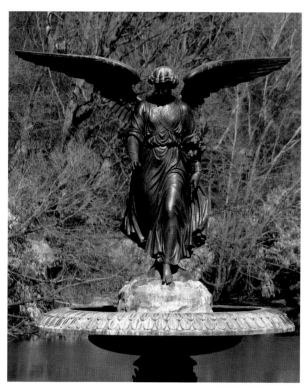

Here are two photos that illustrate the text above. The Central Park statue of the boy and girl (left) was taken with a two megapixel camera. It's certainly adequate at this size print, but will probably look a little less well-defined if blown up much larger. For the Bethesda Fountain angel (right), I used a six megapixel camera, which is my current instrument of choice. I stood about 50 yards away atop the steps and got this very sharp image with a telephoto lens – an image that could be successfully enlarged to a greater size.

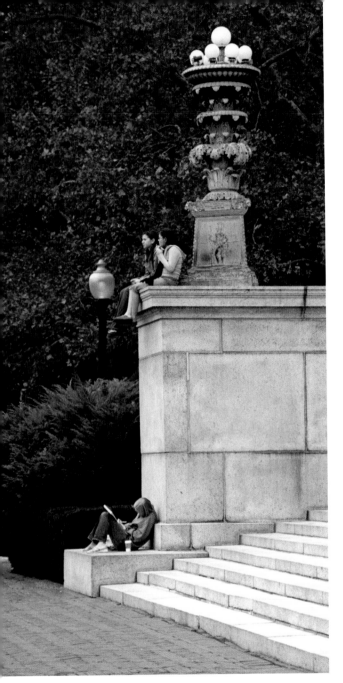

Columbia Double Decker

You can tell from the elongated shape of this scene from the Columbia campus that it has been cropped. There was more in the original picture, but viewing it this way calls attention to the two levels of students.

My favorite photographic activity on the computer is cropping. I've mentioned this at numerous times in the book because it's so basic to good composition. Look at the family and vacation photos in other people's homes. In most cases, they haven't been cropped, and there's just too much non-essential or distracting stuff in the picture. Getting rid of the dross almost always results in a better product.

For a guy like me who's no whiz on the computer, cropping is simple – and it's available in the most basic programs without the need to go to advanced software like Photoshop. You can crop to achieve a certain size – for example, 5x7 or 8x10, producing prints that fit into ready-made inexpensive frames. Or you can crop without restraint, to the shape that works best for the particular picture – oblong, square, whatever. Often, an elongated shape (sometimes referred to as panoramic) makes a lot of sense – as can be seen on the facing page. Sure, you could get a photofinisher to crop a print for you – or you can even print the whole scene and then go at the print with a scissors. But it's not nearly as much fun as doing it yourself on the computer and seeing the immediate results.

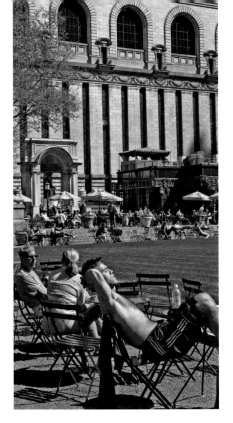

Here are some examples of cropping to achieve an elongated image – vertically, the Bryant Park sunbather (left), and some spring strategizing by principals of *Shakespeare in the Park* (right); horizontally, the last Concorde, grounded alongside the *Intrepid* (below), and a summertime biker sprawled in Central Park (below)

Bryant Siesta

Delacorte Drill

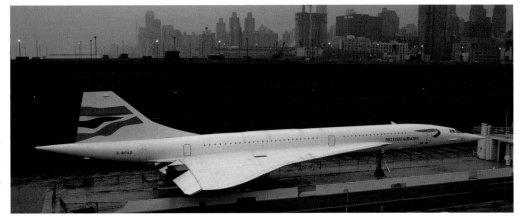

SST in Repose

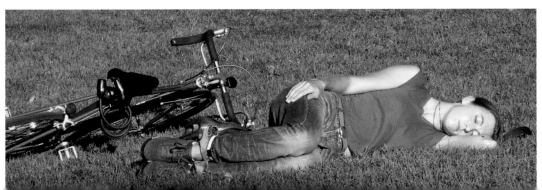

Tour de Snooze

123

There are other structural aspects you can accomplish with more complex programs – such as straightening the picture a few degrees one way or the other, where the horizon or a vertical building is tilted because you didn't hold the camera perfectly straight – but I won't get into these here.

The ability to make color adjustments is a notable feature. You can increase the blue tone of the sky to match what you remember seeing but the camera failed to record. You can reduce red blotches on someone's face. And you can get rid of the "red eye" that spoils many indoor flash photos of people.

One main aspect of digital is your ability to adjust the brightness of the picture, as well as the contrast between its various segments. There are sophisticated programs for this, but also some very simple ones – including computer-suggested one-shot adjustments. This can do wonders in terms of bringing a dull picture to life.

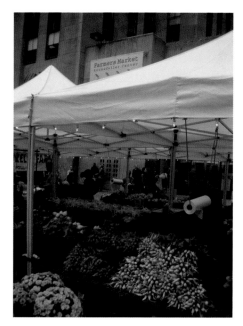 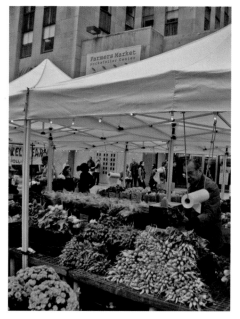

I was delighted one day to come upon a farmer's market smack in the middle of Rockefeller Center. But the day was grey and the resulting digital picture (left) showed it. With a little help from the computer, though, the vegetables and flowers brightened up considerably (right).

Some years back I was in Florence, Italy, standing with my film camera in the alleyway that runs from the Arno River to the square featuring Michelangelo's statue of David. I was trying to use the alley as a frame for a view into the square, but one thing really bothered me. There was a naked light bulb hanging from a wire strung across the alley. If I stood way back to get the desired picture, the bulb and wire ruined the scene. If I moved up underneath the bulb, then I wasn't getting the picture I wanted. Walking backwards to find the best place, I suddenly bumped into an unnoticed man behind me. He turned out to be an artist, seated with his portable easel and oils, observing the same scene. He laughed and said in English, "*I'm* not having any problems with the light bulb and wire." I never forgot that.

Well, now, with digital, you can get rid of such pesky little objects that undercut your picture. It's very convenient, and doesn't really do violence to the main aspects of the picture. Understand, I'm not advocating the old Russian trick of deleting a deposed commissar from the photo to change historical reality. This is small stuff – like an annoying light bulb.

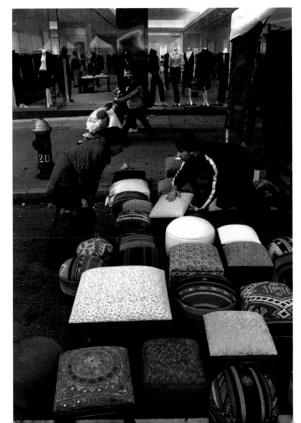

Here's a pretty good shot of hassock-bargaining at a Columbus Avenue street fair (left). But I don't know about that ugly hydrant just to the left of the customer. . . . Don't like it? – Poof! – it's history (right).

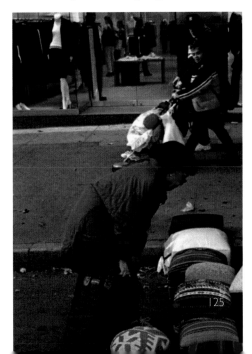

125

Printing your images from a computer is not that difficult. You need a decent printer, but a number of these are available at quite reasonable prices. To make a good print, the real keys are, first, to set your computer to take a little extra time and use more ink to print at higher quality; and second, to use premium photographic paper. You'll really like the results.

I've already talked about how you can go from color to black & white or even sepia. I print many of my pictures in both color and black & white, to see which version most appeals for that particular picture.

I took this picture in color, but the red taillight on the passing car dominated the shot – which was not about the car. So I converted the picture to black & white on the computer, which works better. Now the focus is clearly on the girl's wonderful expression – while still letting the viewer realize that the sitting is taking place right by the curb of a busy street.

Streetcorner Studio

What I did in the *Slices* show, and have been doing ever since, is to blow up the photos digitally to a good size, have them mounted on thin gator board and then laminated for protection. No frames, no expensive non-reflective glass (which I use in framing, because I don't like to look at a picture and see my own face staring back). They're easy to transport and to hang, and they seem to pop out from the wall – especially if mounted to stand out an inch or so.

If you don't feel like printing your images, you can have them put in a book by Macintosh, or create a slide show of your own in the computer, and so on – lots of options.

* * *

I hope you'll find these tips helpful as you go about snapping this photogenic city.

Digital photography does wonders for the flowers peeking through this Central Park memorial bench.

Tribute

(Captions on facing page)

On A Personal Note

I hope this book will encourage others who have pursued diverse careers to consider taking up photography in earnest. For me, the attraction came relatively late in life. Until retirement in 1996, my career was as a business lawyer – a partner in the major law firm of Skadden, Arps, Slate, Meagher & Flom LLP, primarily handling mergers and acquisitions. In later years, I had become more involved in dispute resolution and, from time to time, still act as a mediator in commercial matters.

Back in the '70's, I was a lawyer (far left) specializing in negotiated acquisitions, and wrote a book on that subject, Anatomy of a Merger. *In the '80's, I spent much of my time defending public companies against hostile takeovers, such as the brouhaha involving TWA, which was the subject of a book by Moira Johnston entitled* Takeover *(left).*

"TWA became a crucible that tested three of the principal players—Icahn, lawyer Jim Freund, and Captain Harry Hoglander—as they had never before been tested."

I wrote five other books (below left) between 1979 and 1992, including Lawyering *and* Smart Negotiating, *and also taught lawyers and law students. My last major legal assignment was in Australia, although it didn't require me to wear this hairpiece (below right). Skadden Arps gave me a fine sendoff when I retired in 1996 (facing page, bottom). At a retirement party my wife and I gave for friends, this was the t-shirt worn by the waiters (facing page, top).*

129

Even in terms of hobbies, my lifelong avocation has been playing the piano, in the jazz/popular standards/showtune idioms. Since retirement, I've recorded a number of CD's and performed in some clubs – but my greatest satisfaction has come from playing for singalongs with groups of senior citizens.

My public musical debut took place while I was still practicing law in 1989, resulting in this piece (left) in USA Today. Nowadays, I enjoy playing piano on a regular basis at Hamilton Senior Center and Goddard-Riverside Senior Community Center for appreciative groups of singing senior citizens (below).

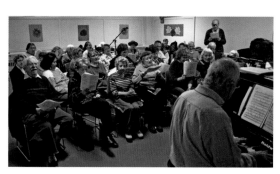

I started to get interested in photography in the mid-80's when my wife (real estate broker/executive Barbara Fox) and I bought a weekend house in Easton, Connecticut – and this big city boy became fascinated by rural subjects. It was during this period that I took up black & white photography and put a darkroom into our home.

This picture was the signature photo from my 1997 "Easton Over Easy" exhibit at the Easton Library.

This picture was the signature photo from my first NYC show, "A Park for All Seasons".

But New York City was still my home town – the place where I had grown up and have always lived. Since we reside only half a block from Central Park, I started photographing Park scenes all year round. The frequency of my visits increased substantially after retirement. Hundreds of pictures, in both color and black & white, filled the walls of our home.

In April-May 2000, about 225 of my Central Park pictures were exhibited in a show entitled "A Park for All Seasons," presented by the Parks Department of the City of New York at its Arsenal Gallery near Fifth Avenue and 64th Street. I collected the photos from that exhibit, together with commentary, in a book entitled *CENTRAL PARK – A Photographic Excursion* (Fordham University Press, 2001).

This was the scene (above) at the opening reception for my Central Park photo exhibit at the Arsenal Gallery in 2000, which led to the book on the same subject (right).

Central Park remains my favorite photographic subject, as you can tell from the number of pictures in this book that were taken within its confines. As an enjoyable sideline, I periodically take groups of people on short photographic excursions to some of the Park's most scenic locales.

Last year, I supplied disposable cameras to a group of students from Paul Robeson High School in Brooklyn and led them on a tour of the Park (above left), ending up at Alice in Wonderland (above right). I then had their films developed and printed, together with enlargements of each student's best shot and a prize to the overall winner.

To balance the time I spend with senior citizens, I've been taking some pictures of the bright energetic youngsters in the second grade at Dalton School where my niece, Alison Hilton, teaches. Here, the group is mugging for the camera after putting on a presentation for the other classes.

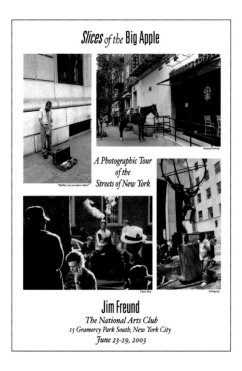

In recent years, with more free time to spend, I've broadened my scope from the Park onto the avenues and cross streets of my home borough, Manhattan, in search of new photographic subjects and locales. It has been an exhilirating experience. When I had assembled 150-plus shots in both color and black & white, I had a "Slices of the Big Apple" exhibit in June 2003 at The National Arts Club near Gramercy Park. This book is a direct outgrowth of that show.

This page contains a poster (top left) from the exhibit (bottom right) at The National Arts Club (bottom left). The exhibit was the subject of a special feature on the cable channel NY1 (above).

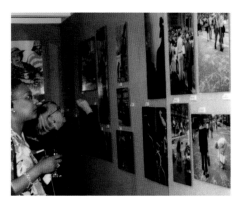

This page is a tribute to my family. My mother, Marcy Freund (top left), is still going strong and refuses to divulge her age (but she does remember waving to the troops marching off to World War I). At the Slices exhibit, she displayed a selection of her paintings, including one she had just completed. Years ago, she helped my father, Sylvan Freund, in the family business, Decorative Plant Corp., which made displays for department store windows and was responsible for the Christmas angels at Rockefeller Center (see p.25) created by English sculptress Valerie Clarebout (far left). That's my mother and father (near left), observing the original display (lower left) being put up in 1954 with a Saks Fifth Avenue backdrop. This past year (above), my sons, Erik (at left) and Tom (at right) both got married, to Wendy and Francie; and my wife Barbara and I adopted an abandoned dog, Buffy, to join bichon Lucy and cat Winky (below).

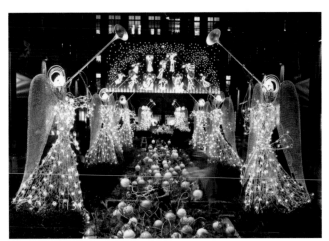

I want to express a special word of thanks to the extremely capable Haesook Han of Pro Image at 289 Amsterdam Avenue, who was responsible for digitally printing many of the pictures in the exhibit (and thus the book), and to her cooperative store manager, Manny Park; to Bert Waggott and his colleague Rosemary Bella, talented graphic designers, for helping shape the appearance of these pages; to Bob Oppedisano, director of Fordham University Press, for enthusiastically supporting the book; to Raymond, who put it all together with great skill and determination; and to my indispensable secretary Ann Leyden, who transcribed my scribblings and took care of a hundred details.

Here's a final proof that the most basic Manhattan ingredients can produce a gratifying image. The drab brown walls of the tenement and the symmetrical ironwork of its fire escape form a mundane backdrop for the splash of color provided by the multi-colored balloons – just another of the many juxtapositions discoverable in the city.

I'll close our tour with this striking image from just above the Mall in Central Park.

Urban Vineyard

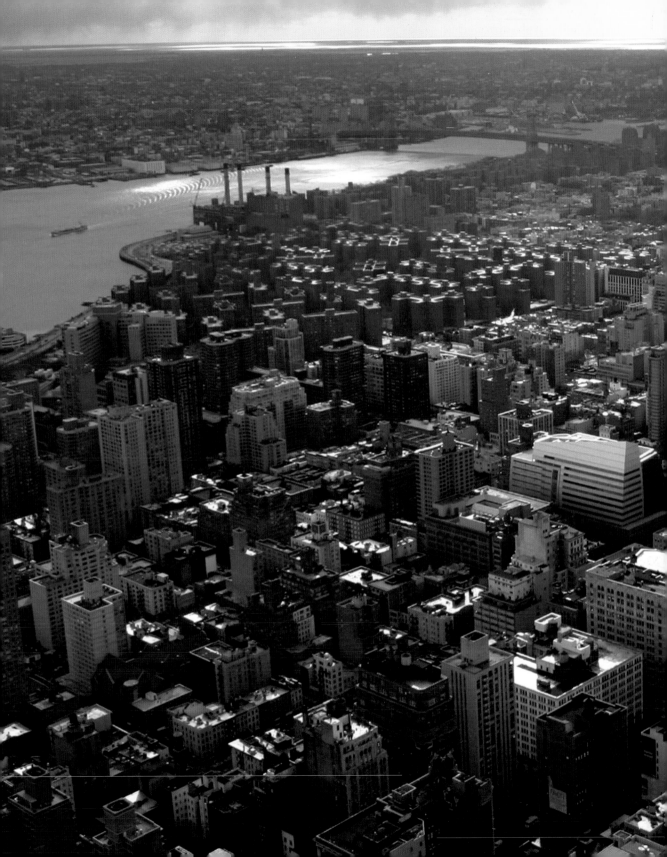